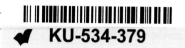

MOUNTAIN PHOTOGRAPHY

MOUNTAIN PHOTOGRAPHY

DAVID HIGGS

DIADEM BOOKS LONDON
THE MOUNTAINEERS SEATTLE

Published simultaneously in Great Britain and the United States
by Diadem Books, London and The Mountaineers, Seattle.

All trade enquiries in the U.K., Europe and Commonwealth
(except Canada) to Hodder & Stoughton Limited, Mill Road,
Dunton Green, Sevenoaks, Kent TN13 2YA.

All trade enquiries in the U.S.A. and Canada to
The Mountaineers, 306 Second Avenue West,
Seattle, Washington 98119, USA

First published by Longman Group Limited 1983
Second Edition published by Diadem Books 1990

ISBN 0–906371–28–7 (UK)
British CIP details available

Library of Congress Cataloging-in-Publication Data:
Higgs, David, 1952–
 Mountain photography / by David Higgs
 p. cm.
 New Edition. Originally published: London, New York, Longman, 1983.
 Includes bibliographical references (p.)
 ISBN 0–89886–257–4
 1. Photography of mountains I. Title
 TR787.H53 1990 90–5850
 778.9′9796522—dc20 CIP

Typeset by J&L Composition Ltd, Filey, North Yorkshire
Printed in Great Britain by Butler and Tanner, Frome, Somerset

To Jane, for tireless typing and stoicism during my long sojourns to the mountains, and to my father, who first taught me the love of adventure and wild places.

ABOUT THE AUTHOR

David Higgs was born in Adelaide, South Australia in 1952. After moving to the United Kingdom and graduating in Biological Sciences at Birmingham University he taught biology in a secondary school for four years. His climbing career began in Australia at the age of thirteen and he has since made a number of notable ascents of difficult routes in the Himalayas, East Africa, South America and Europe.

Now an established freelance photographer and journalist, David Higgs has made two short films for BBC TV and has had illustrated features published in the Sunday Times, Vogue, You magazine, Sports Illustrated, Sports International, Geo, Stern and many other leading publications.

CONTENTS

Acknowledgements ix

Introduction 1

Chapter 1 How to approach mountain photography 3

Chapter 2 How to choose suitable photographic equipment 4

Types of camera 4
Choosing camera lenses 7
Types of film 13
Light meters 16
Camera supports 18
Motor drives and autowinders 19
Flash photography 19
Filters 20

Chapter 3 Handling and care of photographic equipment 22

How to load the camera 22
How to hold the camera 24
How to carry the camera 24
Protecting photographic equipment 25
Caring for cameras and lenses 26
Caring for exposed and unexposed photographic material 30

Chapter 4 How to take better mountain photographs 32

Introduction 32
Exposure 32
How to achieve effective composition 45
Creativity 53
The use of selective focus 54
Filters and how to use them 55
How and when to use flash 59
Nature photography 61
The importance of photographic records and how to keep them 63
Taking record photographs of crags and climbs 64
Aerial photography 65
Common photographic problems and how to overcome them 66

Chapter 5 Special preparations and precautions 70

Planning for long trips and expeditions 70

Photographic insurance 74
Travelling with cameras 75
Avoiding theft 76
Mountain hazards 77
Adapting and making specialist equipment 79
Weather and seasons 82

Chapter 6 How to climb and take photographs 84

Introduction 84
The relationship between the photographer and the climbing team 84
How to take photographs while climbing 87
Taking photographs at altitude 90
Self-photography for the solo mountaineer 93

Chapter 7 How to look after your photographs 95

Editing, captioning and cataloguing photographs 95
Filing and storing photographs 96
Displaying prints and transparencies 97
Slide shows 98

Conclusion 100

Appendices 101
Glossary 104
Further reading 107
Index 108

ACKNOWLEDGEMENTS

We are indebted to the following for permission to use copyright material: Kodak Limited for extract and table on page 101 from pamphlet No. E-30, *Storage and Care of Kodak Colour Materials*; Keith Johnson and Pelling for figure on page 103 from *Rental Schedule*.

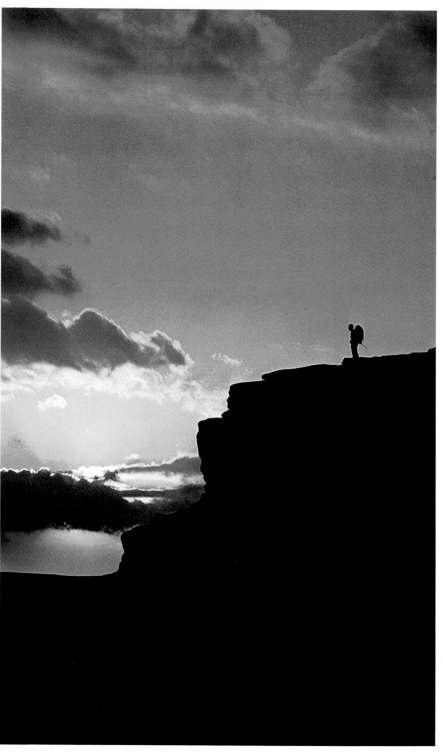

Sunset on Nether Tor in the Peak District.
(Olympus OM2, Zuiko 100 mm, Kodachrome 25.)

INTRODUCTION

Imagine that you are standing on a high, windy mountain peak or a steep slope of ice and rock. The sun is setting. Clouds hanging low on the horizon and in the valleys are tinged with orange and pink. A short distance away are one or two figures in semi–silhouette.

'What a dramatic photograph,' you think. Then the doubts arise. 'Will my camera cope with the low light? What exposure should I choose? If I use a slow shutter speed surely the picture will be blurred.'

This book is intended to be used by the mountaineer and walker to enable him to deal successfully with just such a situation, so that the once-in-a-lifetime photograph won't be a blur or a dark smudge but a record of a treasured memory.

Likewise any photographer who spends his leisure in the mountains and countryside and who wishes to take better photographs will find much useful information here.

The book is written with the needs of the serious mountaineering photographer in mind. Much of the author's experience has been gained on mountaineering expeditions throughout the world and in trying to overcome the problems encountered by a professional who makes a living from the resulting photographs.

The book is presented in seven main chapters with clear explanations and guidance to enable the photographer to take better photographs in most of the circumstances which may be encountered. In addition, the text is supported by a large number of photographs showing what can be achieved and how different techniques and equipment should be used.

In Chapter 4 (pp. 32–69), a section devoted to the diagnosis of common faults in photographs has been included so that the possible causes can quickly and conveniently be worked out. At the back of the book is a list of references and further reading for those seeking clarification or amplification of points raised.

I have included among the chapters one (Chapter 6) which anticipates some of the problems which might be encountered by a serious climber/photographer attempting to record a mountaineering expedition with a camera. It also considers his relationship with the rest of the team and suggests solutions and insights.

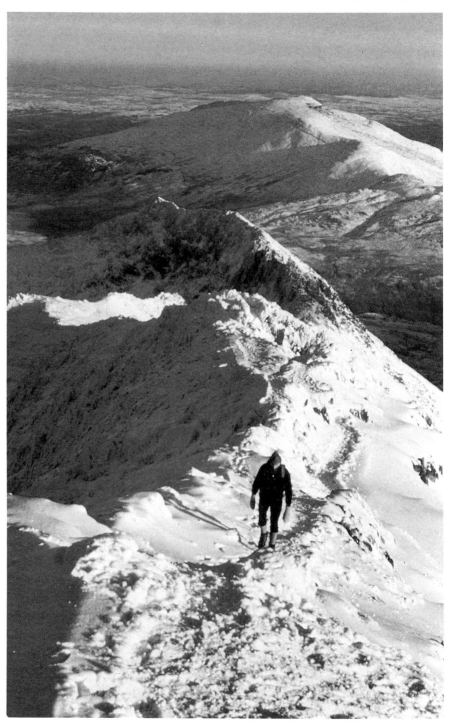

Bright, winter conditions on Crib Goch, near Snowdon, North Wales. In these conditions some mountaineering experience is an advantage. A polarising filter and careful exposure were required to obtain details in the snow and background. Side-lighting was essential to give the impression of depth and to give the snow some texture.
(Olympus OM2, Zuiko 50 mm, from a Kodachrome 25 transparency.)

CHAPTER 1 HOW TO APPROACH MOUNTAIN PHOTOGRAPHY

Many people take up photography as an adjunct to their hobby or main leisure activity. Sometimes along with the wish to make a personal record of one's achievements and experiences there is a desire to be able to use some of the resulting photographs to make money in various ways, to offset some of the costs.

One of the most important things to decide, at an early stage, is why you are taking photographs and what you hope their eventual use will be. A hard but useful lesson has been learnt by many on giving a slide show for the first time or attempting to illustrate an article with photographs. They quickly learn that to give a photographic coverage of one's experiences, and to do it properly, does not merely entail the obvious.

It is important to realise that taking and making good photographs does not come quickly or easily. Careful thought and prior preparation, particularly in the case of a prolonged venture, are essential. You should be clear in your own mind about what you want your photographs to say. You will perhaps make many mistakes but if you keep records it is often possible to find out what went wrong. A fault-finding table has been included in Chapter 4, 'How to take better mountain photographs'.

Above all, be critical. Each photograph you take should be analysed. If it has failed to be successful try to find out why. Sometimes an impartial observer can be more objective and may quickly realise why a photograph did not 'come off'. On the other hand, you should give the same amount of effort to determining why a photograph is good. Only by discovering the components of a good photograph can one hope to capture the magic on another occasion.

One must also try to look critically at the work of other photographers. Do not restrict this to mountain photographs. One can pick up useful techniques and approaches from all branches of the art like fashion, advertising, *avant garde*, industrial and architectural photography. Look at their photographs and when you see a good one try to work out why it has impact. Then apply what you have learned to you own work.

Having considered carefully why and for what purpose you are taking photographs, the next critical question is, 'What type of camera, film, lenses and so on are going to best suit your needs?'

Each aspect of equipment choice needs careful attention if only according to what you can afford. Weight, ease of operation and robustness are also vital factors to consider. No one can tell you what to decide, and it is often difficult to get advice on equipment particularly suitable for the mountaineer and walker. In the next chapter these and many other questions are clarified and some solutions suggested.

CHAPTER 2 **HOW TO CHOOSE SUITABLE PHOTOGRAPHIC EQUIPMENT**

TYPES OF CAMERA

The ideal camera for the mountaineer or walker is small in size, very light in weight, extremely robust and straightforward to operate even when wearing gloves. There should also be sufficient control available over its functions to allow for the vast range of light conditions to be encountered by the photographer in the mountains. In practice one has to compromise considerably.

Generally speaking the more sophisticated the camera, the bigger and heavier it becomes. The trend is very often associated with a decrease in sturdiness. Most modern cameras are becoming smaller and lighter and this certainly applies to those of the 35 mm film format, making them best suited to mountain use. Some 35 mm cameras have been designed particularly for the amateur market and many of their functions are fully automatic, making them especially simple to use. However, this type of camera can leave the photographer with a reduced degree of control over the exposure which can, in some circumstances, be a particular disadvantage. For example, the camera with an integral, coupled light meter may at first sound useful but unless one can over-ride the camera's automatic exposure system great problems may be encountered; for instance, when taking photographs in snow or back-lit situations.

For reasons of size and weight 2¼-inch-square reflex cameras are in general unsuitable for much mountain use, although there is no reason why the keen walker should not use one, provided he is prepared to carry it.

The 110 format camera is becoming increasingly popular and a number of models are very solidly built and sophisticated. However, the quality of the resulting photographs is limited by the small size of the film. Any significant enlargement is marred by grain, lack of definition and reduced contrast.

For the above reasons the following analysis of cameras and their suitability for mountain use is restricted to those of the 35 mm format.

SIMPLE VIEWFINDER TYPE CAMERAS

Many of these cameras are small, light and cheap. Very often they have integral and sometimes coupled light meters. They are generally simple and rugged in construction and operation.

The lens is usually simple in design and has a focal length between 35 mm and 50 mm. These cameras sometimes have interchangeable lenses. One may focus by estimating the distance to the subject, but in case of close-ups it can be difficult to ensure accurate focus. Increasingly, however, these cameras rely on autofocus which can be very accurate, although their close focusing capabilities may be limited. Also, because the viewfinder is offset from the lens, errors of parallax in extreme close-ups may occur, resulting in mistakes in framing the

view because the viewfinder shows an image slightly above and to one side of that which is projected onto the film by the lens.

If the camera has a built-in light meter it is likely to be the sort which takes a general or average light reading. In many cases light-sensitive cells are arranged around the lens or on the front of the camera body. The light meter receives light coming from all sources in front of the lens. This can often lead to accidental under-exposure of the foreground because the light meter is too greatly influenced by light from the sky. One can compensate for this if the camera has some device to over-ride the meter up to two stops over- or under-exposure or by making appropriate alterations to the setting of the film speed. The viewfinder camera makes a particularly good spare camera.

Simple cameras can be of a high quality but they do lack the flexibility of the single-lens reflex camera.

One camera which is worthy of mention is the waterproof model made by Nikon, called the Nikonos. It can be fitted with a 28 mm or 35 mm lens and in many ways it is very suitable for mountain use. However, compared with other viewfinder cameras it is rather expensive. In use, only one problem arises which sometimes catches the photographer unawares. The body of the camera is air tight, and even when ascending only a few thousand feet the expanding air in the camera can push the lens out from the body one or two millimeteres, causing unsharp pictures. This can be overcome by removing the lens from the camera, thus releasing the air pressure. The lens is then replaced.

It is worth investigating the increasing number of weatherproof cameras which are appearing on the market.

RANGEFINDER TYPE CAMERAS

This type of camera uses a coincident-type rangefinder system which is mechanically coupled to the focusing control of the lens. The two images which appear in the viewfinder overlap exactly only when the lens is focused at the correct distance.

Some of these cameras can be quite sophisticated and a few take interchangeable lenses. This does not necessarily mean they are heavy or bulky; in fact, some of the latest are quite miniscule. They are more reliable than simple viewfinder cameras when accurate focusing is critical, but once again errors of parallax must be allowed for when taking extreme close-ups.

Rangefinder cameras may be fitted with a variety of light meters and their various advantages and disadvantages will be discussed later in the chapter.

The most sophisticated of these cameras rival the smallest and lightest of the single-lens reflex cameras in quality and features. Because the shutters are generally of the leaf-blade type they are quieter than a single-lens reflex camera, which has a focal plane shutter. Beware of those cameras which offer an integral or specially designed accessory electronic flash: they can often be under-powered for many applications and some manufacturers do not offer a socket to which a different make of flash gun can be coupled.

This type of camera is often more expensive than the simple viewfinder type.

SINGLE-LENS REFLEX CAMERAS (SLR)

These cameras accept interchangeable lenses. The more up-to-date models are very small and light. Almost certainly they offer the best combination of features for the serious photographer. The lens elements are generally slightly larger than the other types of camera and can be more highly corrected for

Close-up of a footprint on the sands of Lake Paron in the Peruvian Andes. Here a SLR and wide-angle lens were essential to obtain sharp focus and a considerable depth-of-field. The flare was used deliberately to point to the footprint.
(Olympus OM2, Zuiko 24 mm, from a Kodachrome 25 transparency.)

chromatic aberrations and other optical defects. Focus is achieved with the greatest precision because one actually sees the view which will eventually be recorded on the film. For these reasons they are most suitable for producing photographs of the highest quality. Some of the fully automatic varieties do not allow sufficient manual over-ride of the exposure system and this can put a limitation on their usefulness. Some of these cameras do not allow the photographer to manually stop the lens down to the chosen aperture prior to releasing the shutter. This may be a nuisance if one wishes to examine the depth-of-field and make adjustments before taking a photograph.

Because these cameras are sophisticated the photographer may feel dubious about their ruggedness. The best advice is to go by personal recommendation. However, the SLR is not necessarily less rugged than the viewfinder and rangefinder types. Some of the best known SLR cameras have given impeccable service despite being dropped and generally abused, while others have given trouble as soon as they were exposed to dust, freezing cold temperatures and the rough and tumble of the mountains.

This leads to a further set of criteria which the serious mountain photographer would do well to take into account; namely, after-sales service. Some camera importers – certainly until recently – have offered poor after-sales service. Even minor repairs have sometimes deprived the photographer of his camera for not just days or weeks but even several months. One would do well when making a final decision about the choice of a camera to enquire, even from the head office, how quickly emergency repairs can be made.

Many photographers may blanch at the thought of doing their own camera repairs. However, in the mountains simple problems can arise which can put a camera out of action when a little technical knowledge could save the day. Once again it pays to find out whether the importers or sales representatives are prepared to give a brief 'crash repair course', particularly if one expects to use equipment overseas for some time. It is also useful to check the possibility of

buying small numbers of spares in order to do one's own in-the-field repairs. Many of the tools required, such as watchmaker's screwdrivers, are widely used in the jewellery trade and can be bought without too much trouble or expense. Nevertheless, one should be particularly wary of attempting repairs on certain types of modern cameras which utilise sophisticated electronic components. This is why several of the 'old-fashioned' mechanical cameras are more suitable for the adventuring photographer.

CHOOSING CAMERA LENSES

This is an area where individual taste and style is largely the determining factor. The photographer stamps his own style by the way in which he uses the lenses of different focal lengths to achieve photographic effects. However, general guidelines may still be useful to the photographer who is contemplating his first major purchases.

WIDE-ANGLE LENSES

These are lenses whose focal length is less than 50 mm and they can be very useful if handled correctly. They are more tolerant of slight focusing inaccuracies and have a greater depth-of-field. In other words, one can get more of the view in good focus with these lenses. The longer the focal length of the lens the more selective one has to become about what is wanted in focus. Wide-angle lenses are also more tolerant of camera-shake; that is, one can shoot at lower shutter speeds than would be practicable with lenses of greater focal lengths.

Other useful features of wide-angle lenses, at least those in the medium range, are that they are often fairly small, light and compact. They have quite large maximum apertures; and so can be used more easily in low light conditions.

A good compromise lens is one of 35 mm focal length, particularly for someone who wishes to use mainly one lens. It rarely distorts in the way that an ultra-wide angle does, it gives a good panoramic coverage and, above all, is generally cheap.

In some climbing situations one is faced with the problem that it is only safe or possible to take a photograph when the subject is near or at the belay point. Here the wide-angle lens may be the type which is capable of showing the climber *in situ* but also includes a considerable amount of the general view, so putting the subject into a context. This may require a lens of 28 mm focal length or even shorter. Distortion sometimes occurs, however, and one must use skill and experience so that it does not detract from the image.

Distortion generally appears in the form of objects closest to the lens being considerably exaggerated in size. For example, when standing below the subject, his boots may seem to be the size of boats in the resulting photographs. Steep slopes may be rendered disappointingly reduced in gradient when photographed from below. Then again they can appear considerably steeper than in actuality when photographed from above.

STANDARD LENSES

It is sometimes debatable whether to include a normal or standard lens (focal length about 50 mm) in one's kit, especially if one uses a medium wide-angle lens like a 35 mm. When contemplating a long trip overseas or an exacting walk or climb, careful thought must be given to the total weight of gear carried. Sometimes the standard lens can be exchanged for a macro lens whose focal length is in the same range. Despite the prefix macro these lenses take good

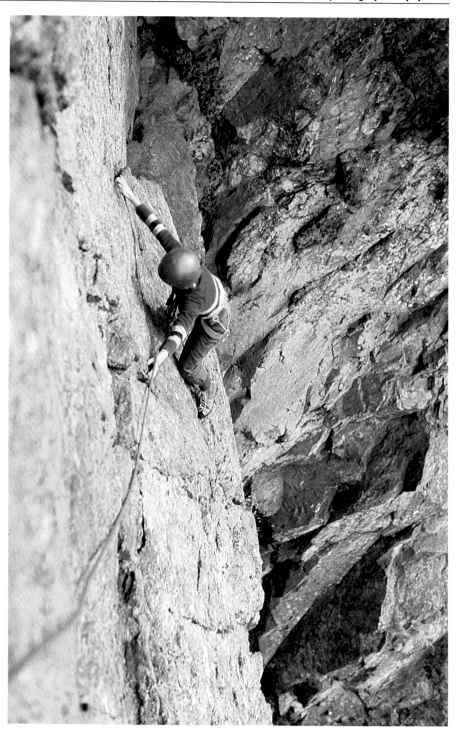

Climber on the last pitch of a climb called Ardus, on Shepherd's Crag in the Lake District. This photograph was taken from the belay point at the top of the route. A wide-angle lens was required and it emphasised the steepness and exposure of the climb.
(Olympus OM2, Zuiko 24 mm, Kodachrome 25.)

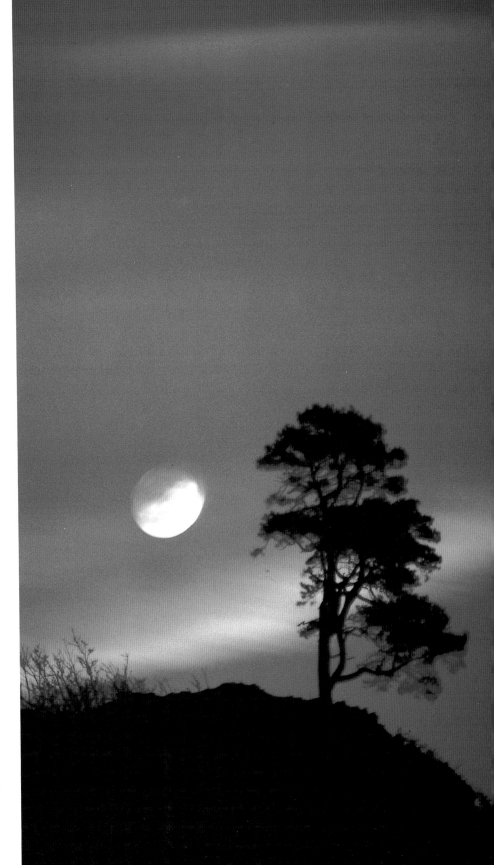

A very long-focus lens was used to isolate the tree and moon. The blurring of the moon and clouds was due to the long exposure of nearly a minute. The time of day for the shot had to be carefully chosen so that the moon would appear sufficiently intense and also to record the deep blue of the evening sky. (Olympus OM2, 300 mm, Kodachrome 25.)

photographs at all distances but are specially designed to take photographs at very close range. These are also useful for recording flora, fauna, medical and general equipment features.

One major advantage that the standard lens has over many others is its large maximum aperture, usually in the range of f1.2–f1.8. In some circumstances where the light is very low this may be the only lens in your possession which can be relied on to get a sharp photograph.

LONG-FOCUS AND TELEPHOTO LENSES

A true telephoto lens has a total length less than its focal length. This is achieved by including a negative or diverging element in the lens, a design generally used for those lenses with focal lengths longer than 50 mm.

When using these lenses one finds they have some handling characteristics which are opposite to those of the wide-angled lenses, eg the longer the focal length of the lens the less camera-shake is allowed. Unless one is using a firm tripod, the principle to be observed is: the longer and heavier the lens, the faster the shutter speed that should be used. For example, these lenses are less likely to yield a sharp image if they experience camera-shake. Telephoto lenses are also far less tolerant of slight focusing inaccuracies and this becomes more pronounced the longer the focal length of the lens. Despite this, they can be very useful, particularly when concentrating on some particular subject, rather than its environment. Then again, when used in the correct manner, they can yield effective landscape shots.

A maximum aperture of less than f3.5 limits the useful shutter speeds available especially when using high-quality, low-speed film in relatively low light.

A lens with a focal length in the range 80 mm to 150 mm is probably the most useful to the mountain photographer; it generally achieves its effect of isolating the subject from the background without sacrificing too much to increased weight and size and reduction in maximum aperture. Generally these lenses can be hand-held and a particularly fast shutter speed is not usually necessary.

A teleconverter, which is a supplementary lens fitted between lens and camera, may be used to multiply the focal length of the lens to which it is mounted. However, it causes a loss of definition and reduction of effective aperture of the lens by one or more stops which lessens its use. Some manufacturers are now overcoming the former problem by producing teleconverters which are matched to a particular lens. In general, though they can be a light and relatively cheap way of increasing the focal length of a lens this must be carefully weighed against the loss of image quality and lens speed.

SUPER TELEPHOTO LENSES

These lenses are often classed as having a focal length which is greater than 200 mm. Invariably they are quite heavy and bulky, although some of the most recent innovations are surprisingly compact. However, as a consequence their maximum apertures are necessarily ungenerous. Their usefulness can be limited, especially if one has little room or load to spare.

Long lenses enable the mountain photographer to obtain valuable pictures of action or interest at a distance. Their narrow angle of view can give the effect of foreshortening perspective, thus seemingly compressing details into little space. By enabling the photographer to stand further away from his subject, distant backgrounds can be made to appear to 'loom' over middle distance details.

Very often long lenses, to be used effectively, require the steadiness of a

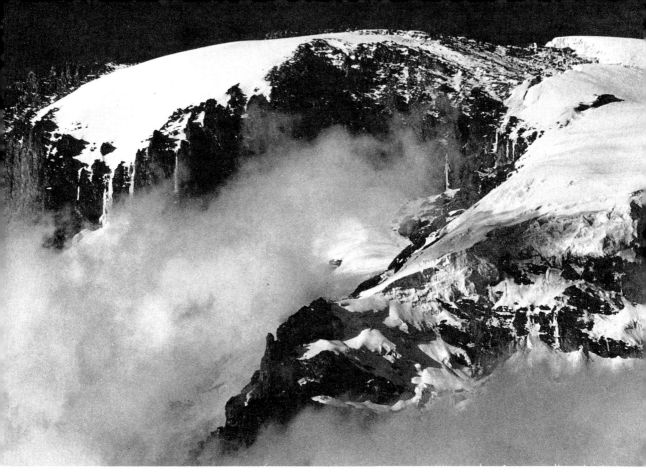

The Great Breach Wall and the Heim Glacier on Kilimanjaro's Southern Flank. A long-focus lens helped to emphasise the imposing and intimidating nature of the face. Only a Skylight filter was used. The sky is usually very dark due to the absence of dust and water vapour at altitude. (Olympus OM2, Zuiko 135 mm, FP4.)

tripod. Even the slightest camera-shake can be greatly magnified in direct proportion to the focal length of the lens, causing unacceptable blur. They have a very shallow depth-of-field and the longer the lens the less the depth of the scene will be rendered in sharp focus. They can therefore lend themselves to certain pictorial effects. For instance, when one wishes to emphasise or select certain details from a scene. Their pictorial use is discussed at greater length in Chapter 4.

Long lenses can be expensive although often less than the ultra-wide lens, whose manufacture is much more exacting. They are obviously well suited to photographing wildlife or taking candid photographs at an unobtrusive distance.

If you do not have, or cannot carry, a tripod, then either fast film or a suitably improvised support may be needed. When shooting distant landscapes atmospheric haze can reduce the apparent contrast and clarity of your photographs. An appropriate filter is required to counteract some of this effect. A filter is limited in its effect depending on the conditions, the quality of the lens and the photographic effect required. The use of filters is covered in Chapter 4.

ZOOM LENSES

These lenses may be seen as an immediate solution to all of the compromises involving choice of lens. Indeed, some of the modern designs, especially those whose zoom range is between 30 mm and 200 mm, will be of great interest to mountaineering photographers.

As a general rule zoom lenses are heavier and bulker than a fixed lens of the same maximum focal length and may have a smaller maximum aperture. In general bulk and weight increase as the zoom range increases while the quality of the optical performance decreases. However, considering that a zoom lens will replace two or three fixed lenses, this may seem a small price to pay. Many modern zoom lenses also feature a useful ultra close-up facility. The minimum realistic limit to the maximum aperture is usually f3.5–f4.5, beyond which it may become difficult to use low speed film in some light conditions.

When choosing a zoom lens remember that you may have to carry it for a considerable length of time, therefore a reasonable upper weight limit is about 700 g (24 oz). A lens heavier than this, especially if one intends to use it exclusively, can become like the well-known albatross. Be careful too that the lens does not suffer unduly from flare. Multicoating of the lens elements cannot always overcome problems inherent in the lens design. Flare is sometimes caused simply by the increased number of lens elements required by the zoom optical system. More elements often mean more surfaces from which light can be reflected back and forth. Flare can even be caused by light striking the front element at a very oblique angle, particularly if the front element is quite large and inadequately recessed. Some lenses now have their own lens hoods which, by careful design, can be compensated for as the focal length changes, thereby eliminating the possibility of the intrusion of the hood at the edges of the picture.

Once again, when trying to make a final choice find someone who uses a lens you are considering and ask his opinion of its performance. Some shopkeepers may allow you to try the lens in the daylight, outside the shop, and this will at least give you some idea of how well it is controlled for flare. Don't forget that most new lenses and cameras are very carefully reviewed in the popular photographic press and one can easily request back editions or find them in a local library.

At this point it should be said that although the large photographic discount stores may offer the best prices they do not always offer the best service or personal interest in your needs. By patronising a smaller firm one can often receive good personal service and in some cases its interest and advice can be invaluable in times of trouble. Such a firm may also, as a result of your patronage, be more inclined to do a personal favour which might be unobtainable in the larger more impersonal, profit-orientated concerns.

LENS HOODS

Most lenses are now sold packed with the appropriate hood; but if you have a lens without a hood you should endeavour to buy one. A lens hood prevents light from striking the front element of the lens at an oblique angle. This light, if transmitted through the lens and to the film, does not contribute to the image but can cause general or partial fogging of the film. This is called flare and it reduces the overall contrast of the resulting pictures. There is no point paying a lot of money for lenses of high quality if you then allow unnecessary flare to destroy the quality of your photographs.

Lens hoods generally screw onto the front of the lens. They are made of

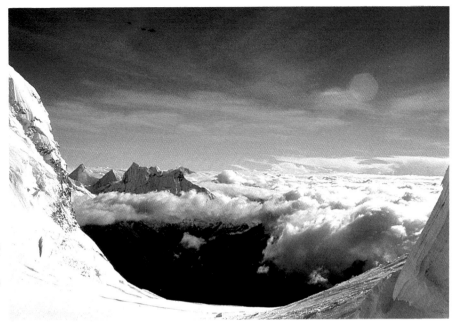

View through the Garganta Col between the north and south peaks of Huascaran, the latter at 6768 m (*c.* 22,500 ft), is the highest in the Peruvian Andes. A zoom lens was useful so that I could frame the background peaks while including the vast saddle from my position on the flank of the south peak.
(Olympus OM2, short range zoom, Kodachrome 25.)

plastic, metal or rubber. The soft rubber variety can be rolled back out of place and therefore when detached can also be stored flat. They are ideal for use on a lens which is used frequently and regularly kept attached to the camera when scrambling and climbing. These hoods, obviously, will not dent or crack. Metal and plastic hoods, though extremely serviceable, must be used with more care so that they are not damaged during strenuous activity.

Wherever possible buy the correct lens hood for the focal length of the lens. The hood should not intrude into the picture but must not be so wide that stray light can enter unnecessarily. If you have to buy a hood for a wide-angle lens check that it will not intrude into the corners of the picture by using the following procedure: Turn the focus control to its minimum and stop the lens right down. Attach the hood, and if the lens is of the automatic variety, press the control to stop the lens down. If the hood is too narrowly angled the corners of the picture will appear dark.

TYPES OF FILM

COLOUR FILM

Colour transparency and negative film is now available in an almost bewildering variety; the photographer therefore ought to know which will best suit his or her purpose. The reasons for taking the pictures will to an extent determine the sort of film which is most appropriate. Remember: if you hope to have colour photographs published in magazines, these are almost never accepted in any form other than transparencies. On the other hand, if photographs are taken mainly for personal interest or exhibition as prints it may be better to shoot colour negative material.

It is always a good general rule to use film of the lowest speed possible for the conditions you expect to encounter. Although films of high speed may be more convenient in terms of their practicality, in low light they are generally

more grainy, lower in contrast and colour saturation and may therefore not be so pleasing to the eye. Furthermore they are not as suitable as lower speed films, which have higher contrast, for producing black and white prints using the internegative method.

Kodachrome is probably the best all-round film, available in ISO 25, 64 and 200★, and prints and projects extremely well. Kodachrome 25 can be a little slow, especially if the light is at all limited. The Agfachromes, Fujichromes and Ektachromes are also of good quality. The ISO 200 films are especially useful in poor or failing light. On a shadowy north face or early in the morning such films may allow one to get shots which would otherwise be unobtainable. However, great care must be taken not to over-expose such high-speed films, especially in snow conditions.

In general colour films, especially transparency material, have less exposure latitude than black and white. They do not give good results if overexposed and very often it is better to err on the side of underexposure if in doubt and retain the detail in highlights which otherwise will bleach out. Colour films are also more limited than black and white in the range of brightness that they can faithfully reproduce. Often I find I have to compromise. To retain detail in certain areas I must sacrifice elsewhere in some highlight or shadow areas.

BLACK AND WHITE FILM

Black and white films usually have a much finer grain than a colour film of comparable speed. For most purposes one will find that a film of ISO 125 offers the greatest flexibility of use, allowing sufficient enlargement to make an exhibition size print (up to 16 × 20 inches) of high quality, while still being fast enough to work in some difficult lighting situations. However, you will find that for general action photography, where fast shutter speeds may be required, film speeds in the region of ISO 400 are more useful. Many of these can be successfully uprated as high as ISO 3200 although increase in grain size and some loss of quality will result.

At the other end of the spectrum are films whose speeds range from ISO 25 to 50. These are exceptionally fine grained, giving prints of the highest quality and allowing a considerable degree of enlargement. Even so, some care must be exercised when determining the correct exposure, as one may find that the resulting negatives are very contrasty. You may obtain a degree of control by altering the speed rating of the film depending on the range of contrasts in the subject. The processing times can then be altered appropriately. Generally speaking, underexposure and/or overdevelopment result in an increase in contrast in the negative; overexposure and/or underdevelopment produces the reverse effect. In other words, where the subject has a wide range of contrast the film can be manipulated to cope by overexposing and/or underdeveloping. In general with black and white photography one is best advised to err on slight overexposure to give adequate shadow detail which might otherwise be lost by underexposure.

Occasionally a situation may arise where you may decide it is advisable or necessary to shoot both black and white and colour film. Obviously if you need both colour and black and white photographs it is better to shoot both types of film. However, this is not absolutely necessary, for if you are shooting high-quality colour transparency and negative film you can obtain black and

★ ISO replaced the ASA measure in 1985 – see glossary.

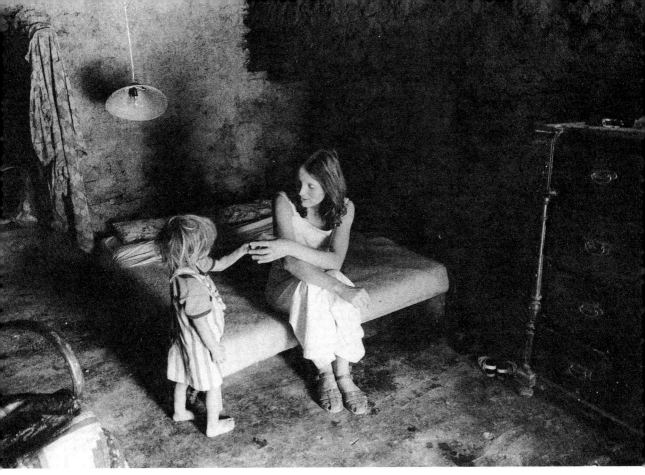

The light which illuminated the room was streaming through a half-open door and a high-speed black and white film, with its relatively low contrast, was required to cope with the situation.

This was an occasion when the subject 'told' me to shoot in black and white. This was partly due to the lack of colour in the room, but I also knew that colour transparency film could not in any way do justice to the subtle range of highlight and shadow details.

Once you get used to shooting a variety of situations in monochrome and colour you soon develop a sense which 'tells' you which film is the most appropriate. Black and white photography really has a magic and a technique all of its own. The monochrome medium can often concentrate attention on details which would otherwise be overlooked or distracted by the presence of colour. For this reason the medium is ideal for 'nitty gritty' documentary photography. (Olympus OM2, Zuiko 24 mm, HP5 rated at ISO 1600.)

white prints quite easily. This is done in the former case by making a black and white internegative, and in the latter by using a special paper and thus obtaining prints directly.

No one is trying to pretend that the quality of a black and white print produced by these methods is necessarily as good as one produced directly from an original black and white negative. However, there are many circumstances where it may be impracticable to use both types of film and the solution suggested may be acceptable in some situations. Of course, if you only shoot in black and white the option of obtaining colour photographs is not available.

INFRA-RED FILM

Infra-red photography is used mainly for technical application. However, it can also produce dramatic unusual results which may interest the creative photographer.

Wavelengths of light which are slightly longer than that of red light in the visible spectrum make up what is called infra-red. At the extreme end of the infra-red spectrum is heat radiation.

Kodak makes film which is sensitive to these wavelengths. As this light is only slightly scattered by dust and water vapour infra-red film can pick out detail which would otherwise be lost in haze.

Black and white infra-red film is also sensitive to the light of the visible spectrum and must be used in conjunction with a deep red or special infra-red filter to eliminate these wavelengths.

In the print, objects which reflect infra-red show up white and those which reflect it less are rendered in tones ranging from grey progressively to black. Grass, foliage and clouds reflect infra-red strongly, while the sky and water do not. This can produce startling and stark photographs with high contrast between sky and clouds, and foliage and surrounding rock and earth.

A false colour infra-red film is also available. This is sensitive to infra-red as well as the visible spectrum but the colours are not reproduced as one would expect. Since the film is particularly blue sensitive a yellow filter must be used. Although blue sky and clouds appear normal, grass often looks red or purple but it is difficult to predict how other objects will appear.

All these films must be loaded in the dark.

LIGHT METERS

The light meter is probably one of the most important and fundamental items of any photographer's equipment. To take good photographs one must be able to use it properly. Gone are the days when photographers used to think that they could estimate the brightness of the light by eye alone.

The light meter is basically an instrument which indicates the intensity of the light and from this the photographer determines the correct exposure; that is, the right combination of lens aperture and camera shutter speed to yield an acceptable photograph for the light sensitivity of the film being used. The human eye is neither as accurate nor as reliable at determining the light intensity; however, this is not to say that the experience and judgement of the person using the meter is not important: they are vital to taking good photographs, and in chapter 4, in the section on 'Exposure', this aspect is dealt with in detail.

There is a wide variety of light meters now available and each has its particular handling characteristics. These need to be appreciated and understood before they can be used correctly.

HAND HELD LIGHT METERS

You may think that a separate light meter is unnecessary, particularly if your camera has one incorporated. However, they can be useful to check your camera's light meter from time to time, for if the latter fails to work, the day may be saved provided that the rest of the camera's functions are operating and that its exposure can be set manually.

Besides the back-up role that a light meter can play it is also a particularly useful tool in determining exposure in difficult lighting conditions. Many light meters, especially those built into the camera, indicate an exposure on the basis of the intensity of light reflected from the surroundings. Where the surroundings have areas of unusually high or low reflectivity some of these may be rendered either under- or over-exposed; for example, in snow conditions. In some of these situations it may be useful to measure the intensity of the light

falling on the scene, that is, the incident light intensity. For this purpose some light meters have a facility for determining exposure based on incident light. In many cases this is in the form of a diffusing cone of translucent plastic which is clipped on to the light meter in front of the light-sensitive cells.

Hand held light meters can also be useful where very long time exposures are required which are beyond the range which can normally be indicated by the camera.

Many of these meters are of the averaging type. They receive light from a wide arc and are constructed to indicate an exposure which is correct assuming that the average reflectivity of all objects in the arc is about 18 per cent. Special 18 per cent grey cards may be bought to help in determining exposure in difficult situations. The use of such meters is discussed more fully in Chapter 4.

Hand held spot meters which measure the brightness of an extremely small area of the scene, are an extremely accurate accessory though they are very expensive.

INTEGRATED LIGHT METERS

Many of the viewfinder and rangefinder cameras have the photoelectric cells positioned around the front of the lens or on the camera body. Generally these receive light from most areas in front of the lens. As already indicated, they can cause problems such as underexposure of the foreground because they can be too influenced by light coming in from the sky area. They do have advantages in that the system is often fairly robust and relatively inexpensive. Once again, these meters are usually of the averaging type.

Through-the-lens metering, or TTL, is probably the most reliable and accurate form of integrated camera metering system because it measures the light intensity after it has passed through the camera lens. Such systems are indispensable when using a variety of filters in front of the lens or when using a camera to which many different lenses may be fitted.

TTL metering comes in many forms, the main ones being, averaging, centre weighted, and spot. As already described, the averaging meter indicates an exposure based on the total amount of light passing through the lens. Spot meters on the other hand only read the light coming from a very small area or spot near the centre of the field of view. Such a system has some advantages, and if used to meter areas which one wishes to be exposed normally may not be so overly influenced by large but perhaps unimportant areas of darkness or light. Nevertheless they have to be used with reasonable understanding of the problems of exposure to yield optimal results. For example, because they read from such a small area the spot meter, if pointed to an area which is much darker or lighter than the rest of the scene, will indicate an exposure which may be greater or less, respectively, than that required by the scene as a whole.

Many cameras use a system which is mid-way between these two, called centre-weighted metering. This assumes, as in spot metering, that the area of greatest interest is towards the centre of the picture and is specially biased to expose more for this area than the areas surrounding the centre. Often the area to which the meter is weighted is below and towards one side of the horizon of the field of view. This is an effort to overcome any tendency of the meter to be too influenced by the large areas of sky and to compensate for this even when the camera is turned on one side for a vertical format shot. The latter bias does assume that the photographer remembers to keep the correct end of his camera down when taking such shots. Nevertheless, such systems do in fact prove to be very reliable and accurate but once again the key to good photography is a thorough understanding of how your camera's light metering system should be used.

CAMERA SUPPORTS

It is usually enough to hold the camera steady when you press the shutter. You know the picture will be acceptably sharp. However, depending on the lens to be used (its focal length and weight) and the length of exposure required, you may need some kind of camera support. The most commonly used is the tripod but for the mountain photographer this raises several problems. Once again you must appraise carefully the types of photographs you hope to take. How often do you think you might need a tripod? In a later section various methods of improvised camera support will be dealt with and some of these may allow you to dispense with a special support. However, tripods are especially useful for close-up work and become indispensable for long time exposures and when using lenses of very long focal length. A cable release is often required in these circumstances to prevent any vibration which might occur if the camera were touched.

The rigidity of the tripod and its weight are generally linked in fixed proportion. A very small, lightweight tripod may be so rickety that it is nearly useless when required for long time exposures. The legs of the tripod need to be spaced well apart if they are to provide a stable base, say in high wind. Portability is often a critical factor and this will limit the weight and size of the tripod which is used in the mountains. Often one can make do with a relatively lightweight and compact tripod provided that it is well constructed and robust. In windy conditions a heavy weight like a rucksack or rock can be suspended under the tripod's centre to give the extra stability required.

Most tripods have telescopic legs. Unless carefully designed each extra leg section will cause a further degree of play in the legs and consequently affect the tripod's general stability. Leg sections are generally locked in place in one of two ways. Camming levers are one type. In an environment of dust and grit they may wear quickly and after some use the leg section may slip because the bearing surface for the cam has been worn away. It is always a good idea to check that each section locks securely before purchasing. Remember that one rickety leg may make the entire tripod unstable.

The second type is locked by rotating a knurled ring at the junction between the leg sections. Some of these operate a simple cam system. Once again some of the cheaper versions can wear quickly, particularly if grit and sand get inside the tubular legs. Others operate a little like a drill chuck. This sort is often most reliable because a satisfactory lock can still be obtained despite wear. The one disadvantage of this system is that it takes longer to set up and lock the legs of such a tripod than one with the camming system.

Some very small stands, are also available, sometimes only a matter of inches high. If you feel it prudent to carry some form of camera support these may be worth considering but usually they will only work satisfactorily on a flat or level surface.

Finally, it is worth mentioning about types of heads of tripods. The head is the part to which the camera is attached. Some of the smaller and cheaper tripods have a ball and socket head and these can be unsatisfactory, especially when using heavy lenses such as telephotos. Sometimes the clamp device is not capable of supporting such a weight securely. The more traditional pan and tilt head may be found to work more successfully.

Monopods are generally of little use for still photography in the mountains unless you will be doing a number of panning shots with a moving subject. Very often one can obtain similar support using an improvised technique. Of

course, if you intend to use a movie camera as well then the monopod becomes a useful piece of equipment. Nearly all are made of tubular sections using one of the latter two types of locking mechanisms. There are also a variety of clamps with ball and socket heads, some of which can be attached to the top of an ice axe.

MOTOR DRIVES AND AUTOWINDERS

Both these devices trigger the shutter, advance the film to the next frame and cock the shutter ready for the next exposure. Autowinders repeat this sequence once, for every time the button is pressed, whereas the motor drive will continue to repeat the sequence at a set number of frames per second for as long as the button is depressed.

These devices are not generally necessary for the mountain photographer unless he is doing certain types of action photography, or where cameras need to be operated by remote control. The advantage of this equipment is that photographs can be taken more rapidly than when the camera film advance is operated manually. It also makes the camera much easier to operate with gloved hands or frozen fingers.

The disadvantages are that they are often heavy and increase the bulk of the camera, particularly in the case of the motor drive. Because they are battery powered they are also adversely affected by extreme cold and a good supply of fresh batteries may be required in sub-zero weather. When used in conjunction with a remote triggering device an autowind can be useful to the solo mountaineer who requires a good photographic record of his exploits. Auto-winders, and particularly motor drives, may cause problems in extreme cold by tearing the sprocket holes in film if it becomes brittle. Many of the latest cameras have integral motor drives and film winders. These are battery-powered and are, therefore, vulnerable to battery-drain in cold weather and, should the winder mechanism fail, can become unusable. For this reason it may be wise to carry a compatible mechanical body. For more details on remote triggering devices see Chapter 6, 'How to Climb and Take Photographs'.

FLASH PHOTOGRAPHY

With the advent of small but powerful electronic flash units, these have become increasingly useful to include in one's equipment. They are also valuable for shots where natural light is limited, for fill-in lighting and close-up work.

It is best to choose a flash gun which has a guide number allowing you to work at a reasonable, say up to 5 m, distance with your preferred type of film. However, it is a general rule that the more powerful the flash gun the bigger and heavier it becomes. Modern flash guns have a slightly tinted discharge tube or reflector so that additional warm filtration is not required. The tinting is necessary because the light produced by electronic flash tends to be rendered as bluish on daylight type films.

Some flash guns can be set to work automatically or can be set manually to decrease the duration of the flash in fixed amounts. Usually this is indicated in the form of ½, ¼, ⅛ of full power and so on. This facility makes these guns particularly flexible in use and ideal for flash fill-in and close-up photography.

Flash bulbs offer a way of providing artificial lighting. Their main disadvantage is that a flash bulb can only be used once. A new bulb is required for each photograph, whereas an electronic flash gun can provide hundreds of flashes from one set of batteries. The advantage of bulbs lies in the fact that they are

often lighter and more compact than many flash guns and often produce a light of much greater intensity than would be possible from even a very large, professional, electronic flash gun.

Bulbs can be used with little problem with leaf-blade shutters, usually fitted to viewfinder and rangefinder cameras. The notable exception is the Nikonos, which has a focal plane shutter. The latter shutter type is usually associated with SLR cameras. Flash bulbs rely on the ignition of fine metal foil or wire, and special long burning bulbs are required when one wishes to use them with focal plane shutters, and with shutter speeds higher than that usually used for flash synchronisation. In most cases with focal plane shutters flash synchronisation is achieved at shutter speeds between ¹⁄₆₀ and ¹⁄₂₅₀ of a second.

FILTERS

Filters are generally fitted to the front of the camera lens and alter the optical properties of the light before it enters the lens. In a few cases the filters are inbuilt (and thus must be dialled into position) or are fitted to the back of the lens. These latter systems are used when the design of the lens makes it impracticable to add filters to the front of the lens. The creative and technical use of filters is discussed more fully in Chapter 4 in the section, 'Filters, and how to use them'.

For the mountains a very useful filter is one which will absorbe some ultra-violet light. In black and white photography such a filter (UV absorbing) reduces the effect of haze. In colour photography a Skylight filter (1A or more recently 1B) does a similar job. These also have a slight pink tint which helps counteract the bluishness produced on colour transparencies by excess ultra-violet. The latter type of filter can be used equally successfully in black and white photography but a UV filter is not really recommended for general colour photography. It is a good idea to have a Skylight filter fitted to all camera lenses as this protects the vulnerable front element from physical damage. Such a filter can be left permanently attached to the camera lens for all general photography and in the mountains its protective function cannot be underestimated: a filter is much cheaper to replace than a broken lens.

Other useful filters for black and white photography are red, orange and yellow. Polarising filters are very serviceable, particularly to reduce haze and darken sky tones when photographing landscapes, so increasing the general contrast and colour saturation in these regions. They are equally effective when used with black and white film. Useful but less often used are close-up and star-burst filters. There is also a wide variety of special effects filters such as graduated filters which can be used to darken or colour sky or foreground, and the recently introduced dichroic filters which produce a variable amount of tint to the whole of a colour photograph.

If you have a number of lenses it is likely that some will require filters of different sizes. It is a good idea to have at least a Skylight filter or an ultra-absorbing filter and a polarising filter to fit each. However special effects filters and others which you will use occasionally are often best bought to suit the largest of your lenses or purchased as square filters which clip into a holder and can be attached to different size lenses using the appropriate adaptor (e.g. the Cokin filter system).

A useful acquisition is a set of the necessary 'stepping rings', which are mounts which screw into the front of the lens and accept outsize filters. You may also use stepping rings in combination; in this way a lot of money can be saved by not buying unnecessary filters and adapters. Furthermore this reduces the bulk of accessories to be carried.

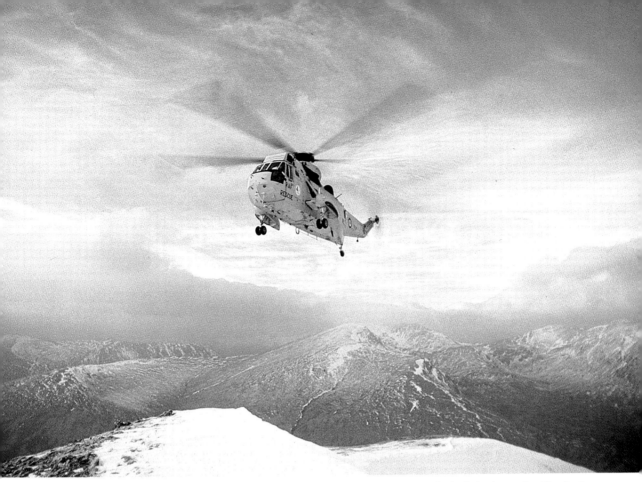

RAF Sea King helicopter flying over Carnegie near Loch Mullardoch, in the north of Scotland. The helicopter dropped me on to the summit but despite flying suit and mitts my fingers were wooden within minutes. A polarising filter gave me a more saturated blueness to a fairly white sky. In fact the subtle details in the sky and surrounding hills 'make' this photograph and the bright yellow helicopter provides a good 'focus' for the eye.
(Olympus OM2, Zuiko 24 mm, Kodachrome 64.)

Filters usually come in their own fragile plastic case and they may appear cumbersome, as half a dozen of them may take up as much space as a lens. This may be overcome by using 'stack caps'. The filters are first screwed together to form a unit; caps similar to some types of screw-on lens cap are then screwed on to each end. The whole unit is now much reduced in bulk and the likelihood of dust entering is almost eliminated. In this form they are also surprisingly well protected from physical damage and a very heavy blow would be required before the actual glass elements were damaged.

CHAPTER 3 HANDLING AND CARE OF PHOTOGRAPHIC EQUIPMENT

HOW TO LOAD THE CAMERA

Before any photograph can be taken film must be properly loaded into the camera and when all the film has been exposed it must be unloaded. This may seem a basically simple procedure but in fact mistakes can be made which can adversely affect the quality of the resulting photograph.

Try to avoid where possible loading or unloading the camera in direct sunlight. It is often sufficient to turn your back into the sun or, if it is overhead, to stoop over the camera so that it is in the shade. Sometimes one can find a shaded place which may be more convenient. This is necessary because strong light can occasionally expose or fog the outer part of the film roll despite the film cassette and felt light-trap.

Check that the exposed film has been rewound before opening the camera back. The camera back is usually opened by either firmly pulling the knob on the rewind spool or by releasing a catch. Check that the camera back is free of fluff or dust. Particles of grit can damage the film emulsion as it is being wound and cause parallel scratches called 'tram-lines'. Check that the new cassette and film leader are clean and free of particles or stray bits of felt from the light trap.

Despite the fact that there is a wide variety of 35 mm cameras available today, the basic principles of loading or unloading film are all very similar.

There is also an increasing number of cameras with auto-load facilities. Whichever type of camera you use be careful to follow the makers' instructions carefully. Before you start taking photographs be sure that the film is winding on properly. Some cameras have devices built-in to warn the user if the film loads incorrectly.

The following advice applies especially to cameras which are loaded manually. The new spool is placed on the left-hand side of the back of the camera, the felt trap to the right. Now re-engage the film rewind knob into the top of the cassette. The leading end of the film is now inserted into the take-up spool so that its end is held firmly. Advance the film until one full turn has wound on to the take-up spool. This will prevent the leading end accidentally coming free from the spool which would result in the photographer getting no pictures at all. Now wind on one more frame to check that the film is paying out smoothly.

Once the camera back has been closed take in any film slack by rewinding gently until a resistance is felt. This shows that the film is held firmly inside the camera. Wind on two more frames, watching for the rewind knob to begin to rotate. This shows, that the film is paying out correctly. Once this has been done any already exposed film has also been wound on to the take-up spool. It is often a good idea to watch that the rewind knob rotates as you advance the film after the first few shots and to check it occasionally thereafter.

When you have finished a roll of film don't forget to operate the control which disengages the take-up mechanism. Otherwise, as you rewind, the sprocket holes will be torn and it will be unlikely that the film can be processed. Always rewind the film slowly and steadily. Too much haste in rewinding – particularly in dry conditions – can generate a static electric charge on the film which if it is discharged will cause a spark which can fog the film.

Bivouac on steep ice on the north-east face of Alpamayo (5947 m/19,511 ft).
At night at such altitudes the camera has to be kept in the sleeping bag to prevent the freezing of any condensation or moisture. A wide-angled lens was required in order to include the other climber who was only a few feet away from the photographer.
(Olympus OM2, Zuiko 24 mm, Kodachrome 64.)

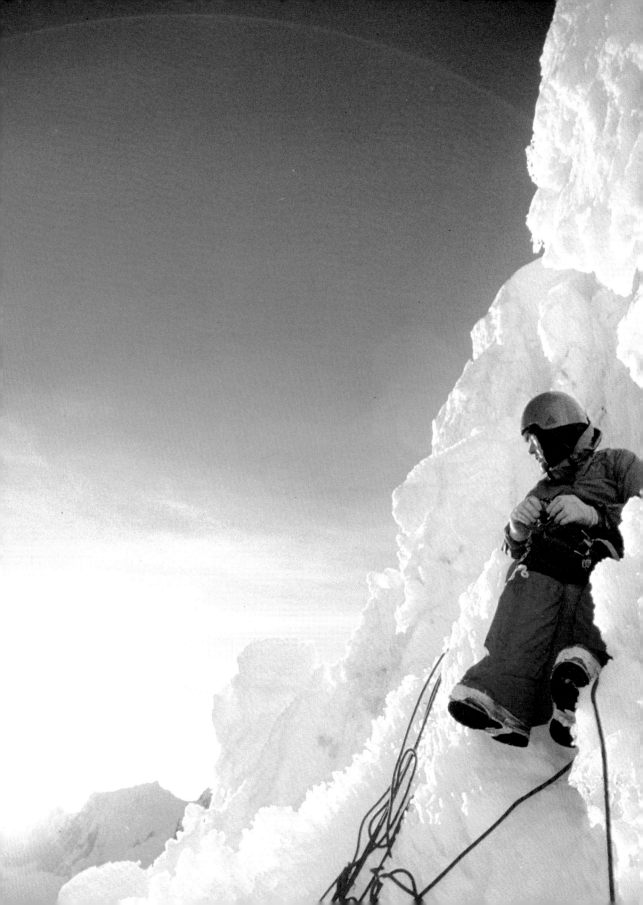

Be very wary of those cameras which have no manual means of rewinding film. It is conceivable that at some time the automatic rewind may fail leaving you in a very difficult situation with the risk of ruining precious exposed film or not being able to reload. In such a situation a changing bag would be very useful.

Always place the removed film immediately into the light- and air-tight container in which it was supplied. This is most important. For further details see the section on caring for film later in this chapter.

It is important to adopt the same procedure every time when loading and unloading film. This will make accidents far less likely and will enable you to become quickly practised at the procedure even in adverse conditions.

HOW TO HOLD THE CAMERA

One of the big enemies of novice and professional photographers alike is camera-shake. Remember that the shutter speed control determines for how long light from the subject reaches the film. If you or the subject move while the shutter is open the image will move fractionally and the photograph may be blurred.

However, successful photographs even at a relatively low shutter speed can be achieved by obeying a few simple rules: before releasing the shutter hold the camera firmly against the eye and cheek bones. One hand should grasp the right side of the camera, with the finger resting on the shutter button. The other hand may be placed under or around the lens or else firmly grasping the left hand side of the camera. The former grip is recommended with SLR cameras particularly when using a long lens. Remember, never let your finger get in front of the lens otherwise the shot will be ruined. The feet should be a comfortable distance apart with the knees unbent if possible. Just before releasing the shutter consciously steady the body and bring the elbows in tight against the sides of the chest. Hold your breath as you squeeze the shutter button. Never jerk down upon the shutter release. The technique is similar to that used when firing a rifle and is the best to ensure as little camera movement as possible. You should try to adopt this stance whenever taking a photograph.

Additional support is required when taking photographs at the slowest shutter speeds. You may rest the camera against a fixed object like a tree or boulder or even on the ground, a rucksack or ice axe. In fact, even the shoulder of a companion may be used for support if using a particularly long lens. Another good way to steady the camera is to go down on one knee and rest the elbow of the arm holding the camera on the raised knee.

If a time-exposure is required and a tripod or similar stand is not available the camera may be rested on any fixed object and propped in position. The delayed timer can then be used to trigger the shutter. This technique is surprisingly effective and often results in no distinguishable camera-shake even over quite long exposures of several seconds. Of course a medium length cable release of 30–45 cm (11–18 in.) can be used but one must be very careful to use it gently because the camera is not being held in place as securely as when attached to a tripod. It is not a bad idea to make repeat exposures in these situations to ensure that at least one shot is unblurred.

HOW TO CARRY THE CAMERA

To get good photographs the camera and the more important accessories must be kept readily available for use. This may seem too obvious to mention but

how often have you missed good photographs because you couldn't get a camera out in time or because you couldn't be bothered to retrieve it from the bottom of a ruckcask?

Very small cameras can be carried in trouser, anorak or breast pockets and this also serves to protect them from the weather. One of the best ways to carry a larger camera is with the strap over the head and one shoulder. The strap should be kept as short as possible. This will prevent the camera from swinging about as you walk. Often a well-protected place for the camera is under the armpit. When scrambling or climbing the camera strap can be pulled so that the camera rests across the back or behind the armpit. Very often it is enough if it stays at the side. Always remember to place the camera strap over your shoulder after putting on the rucksack, otherwise it will be trapped under the straps.

Another alternative is to have the strap over the head with the camera resting on the chest. A broad elastic ribbon can then be placed over the straps just above the camera or over the camera itself to prevent it banging against the chest. This and other versions of the Cuban hitch can be developed to suit the individual's needs.

These two methods of course can become impracticable in bad weather but can often be surprisingly easily overcome by making your own weatherproof case using many of the materials suitable for outdoor garments. With some ingenuity, and with a camera of suitable design you will find that one can make even an SLR camera almost completely protected from weather as well as from accidental knocks.

It may also be useful to decide whether a broader and possibly stronger camera strap may be more comfortable, especially when one has it slung around the neck for several hours a day. Many forms of synthetic webbing are particularly suitable and are widely available.

Spare film containers can be taped to the camera strap, but don't forget that this will sometimes expose them to wide variations of temperature – something which is not good for film, especially colour materials.

One can even customise clothing to accept the various accessories which need to be kept close at hand. Simply enlarging some pockets may be sufficient or you can make or buy gadget belts to be worn around the waist to contain small accessories. The lengths to which you can go depend on your needs, aspirations, dedication and ingenuity.

PROTECTING PHOTOGRAPHIC EQUIPMENT

In the mountains it is important that photographic equipment is adequately protected from knocks and vibration. Equally it should be protected from the effects of dust, water and humidity which can eventually be just as damaging.

Most cameras and lenses and many other accessories if bought new are supplied with a case. However, you should be very careful to keep the bulk of equipment down to a minimum, particularly if carrying it yourself. Try to maintain a careful compromise between too much bulk and too little protection, perhaps economising by not having every item of your gear in its own case.

Remember that most bags and cases are not waterproof and that if you intend to work in extreme conditions some equipment will have to be improvised or made entirely to suit a purpose.

When planning a trip overseas, a very strong case, such as those made of reinforced alloy, may be useful. They are generally expensive and bulky, so try to buy one which is not any larger than is necessary. Remember also that a case which is obviously for photographic equipment can be an invitation to thieves.

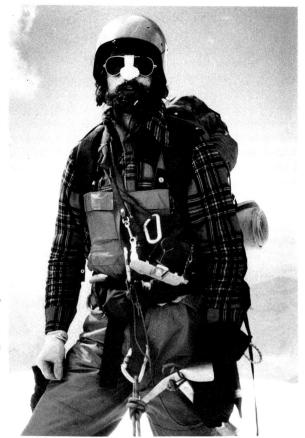

The author on the summit of Alpamayo in the Peruvian Andes (5947 m/19,511 ft). We spent one and a half days of difficult climbing on steep ice to reach the summit. Initially we had to climb half of the face at night by the light of head-torches in order to avoid the stone and ice fall which occurred in the heat of the day. A good strong case and strap were required on the camera to preserve it against damage which would have resulted from the knocks and rough treatment it received. The case I designed was reasonably water- and snowproof and enabled me to take photographs without the need to remove it. Around my waist I had a belt containing two lenses, and film.

For this reason a soft gadget bag or a more general bag suitably customised may be less conspicuous. Keep in mind too the constraints on hand luggage presented by travel, particularly on the airlines. Make sure you buy a case which can be stowed easily under your seat or in the locker provided. Always try to keep valuable equipment near or on your person.

The subject of making and customising equipment is dealt with more fully in Chapter 5.

CARING FOR CAMERAS AND LENSES

TIPS ON CLEANING LENSES AND FILTERS

To a large extent the quality of a photograph depends on the quality and state of repair of the lens with which it has been taken. Dust, grease marks and scratches on a lens all reduce the contrast and sharpness of the resulting image. This applies equally to filters and other devices through which light will pass before reaching the film.

Use a soft-haired brush (fine camel hair is recommended) to clean lenses and filters of dust or fluff. These brushes are widely available in most photographic retailers. Some brushes have a rubber bulb attached so that air can be pumped

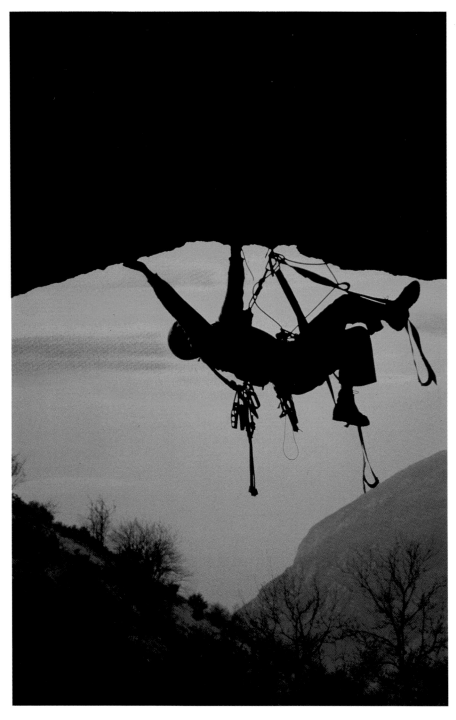

A climber hanging from an artificial route across the roof of Dove Hole cave in Dovedale, England. Great care is required to protect the camera from water and knocks in these situations. (Olympus OM2, Zuiko 100 mm, Ektachrome 200.)

on to the lens at the same time as one is brushing. These 'blow' brushes are especially useful.

Sometimes dust cannot be easily removed and here the modern aerosol dusting devices are invaluable. Most have a fine nozzle which directs the jet at any stubborn particles. On a long trip it is worth taking a small aerosol as part of your kit.

Grease and finger marks are often best removed by using lens cleaning fluid. Soak a small segment of paper tissue with the liquid and brush gently across the mark until it is removed. Never scrub the lens.

Modern paper handkerchiefs are lint free and sufficiently soft to be used for a variety of lens and camera cleaning purposes. In fact lens tissues as sold in many photographic stores are unnecessary. A paper handkerchief does the job as well and more economically.

Other good solvents for freeing lenses of grease include alcohol and petroleum ether. The latter evaporates very quickly and is a very good solvent. It also leaves no drying marks behind. All these solvents must be kept in an absolutely leak-proof container. A screw-top bottle or can with a non-absorbent seal is best. Check that the container is really leak proof before standing it on its side or upside down in a photographic case.

Cameras and lenses which have been out in the cold should not be suddenly exposed to warm moist air such as one finds indoors. Condensation can rapidly form on the outside and inside of the equipment and this can cause electrical problems with some cameras as well as increasing the risk of corrosion damage in the long term. If the equipment is inside a rucksack, case or bag it should be left to gradually equilibrate with the ambient temperature before it is unpacked.

Try to avoid breathing on the lens too often when cleaning. In extreme cold this condensation will freeze either on or inside the lens and create even more problems. Always try to dry off any superficial water on the lens or lens barrel before storing and try to keep the lenses as dry as possible. If a lens has been subject to high humidity it is a good idea to pack it with silica gel in a sealed plastic case as soon as possible. Leave it for at least 24 hours to dry out. If a lens has had a really bad soaking in fresh or rain water get the lens into a warm dry spot as soon as possible to dry it out. Of course all superficial water must first be removed. Worn iris blades can rust rapidly if not dried quickly and can become seized. Try where possible to dry the lens with the lens stopped down completely and from time to time move the iris blades in and out using the depth-of-field preview button to aid the evaporation of water.

TIPS ON CLEANING CAMERA BODIES

Camera bodies must be kept free of dust and fluff, particularly inside. Whenever possible brush or blow out the back of the camera body before loading a new film. Use a slightly stiffer brush than that employed for lens cleaning. Check that the grooves into which the camera back makes a light-tight seal are free of any particles.

If your camera has a focal plane shutter ensure that the grooves along which the shutter blinds run do not hide any fluff or projecting flock which may have been dislodged. To do this put the camera onto the B setting and press the shutter. Holding the shutter button down, remove the lens or body cap and hold towards a white or brightly lit surface. By looking through the back of the camera one can then easily pick out, with a pair of fine forceps, any offending particles of fluff. It is in fact quite surprising what can find its way into a camera. Human hair is one of the biggest nuisances next to fragments of flaked film emulsion.

This is my repair kit which I use on expeditions and assignments. The plastic box measures only 18 cm × 13 cm × 5 cm. One can pack a lot into a small space with a bit of thought and ingenuity. The box is divided into layers with 1 cm thick polyurethane foam.

The kit comprises: 7 watchmaker's screwdrivers, 4 pairs of forceps; lens tissues and cloths; spare camera batteries; very heavy terylene thread; super glue; 1 pair of dividers; 1 small pair of pliers; watchmaker's oil; spare camera top cover; camera-back, pentaprism; and viewfinder lens, screws, etc. The bath plug is used to remove the retaining ring on the front element of most of the lenses!

The outside of the camera, not forgetting the viewfinder eyepiece, should be cleaned and dusted whenever possible. Grease marks can be removed as for lenses. Remember that dust and fluff on the outside of the camera can find its way inside through the various apertures on the surface. Always cover cameras and lenses when they are stored. It is not a bad idea to seal them inside a plastic bag with a sachet of silica gel.

REPAIRS IN THE FIELD

It is difficult to give specific instruction on what to do if a camera or lens breaks down. If you are going on a protracted trip overseas you may be able to arrange a 'crash course' in elementary repairs with the camera or lens maufacturers or sales representatives. You may also be able to buy a few basic spares. These include viewfinder eyepieces, which often do get damaged, or battery cover plates. You will have to contend with the fact that in the majority of cases you will only be able to do very basic repair jobs and it will of course be at your own risk. Almost certainly the guarantee on your camera, if still in force, will, as a consequence of your interference, become null and void, especially if it is obvious that you have tampered with the camera or lens.

Sometimes, minute springs and catches, especially those controlled by the 'depth-of-field' preview button, which have been dislodged by a jar or knock can be put back into place with just a little care and know-how.

Due to wear and tear focusing rings may begin to slip or the knurled rubber grips on them can come loose. Simple mechanical problems may also arise with flash guns, tripods and many other items of equipment. A small repair kit containing suitable screwdrivers, forceps, glues, small pliers and spare batteries may be particularly useful in the mountains. You can also include specific spares for your equipment. Keep these together in a small waterproof container. Other such items such as a selection of brushes, lens cleaning fluid, tissues and spare

lens caps are essential for the serious photographer. If you are at a loss to find suitable containers slide boxes are a useful stopgap.

According to a number of camera manufacturers the most common cause of malfunctions, especially of TTL exposure metering and electronic shutters, is battery failure. Silver oxide batteries are still the most commonly used in many makes of camera. These may be prone to corrosion due to a process called 'gassing' and a white crystalline powder is sometimes formed. This deposit is often enough to prevent the flow of electricity to the camera and can occur in conditions of high humidity.

If your camera should suddenly stop working or the meter fails to register always check the battery before suspecting any other cause. I have found the problem can be quickly overcome by scratching the contact surfaces of the battery with a penknife blade to move any oxide layer which may have built up. If the battery is obviously gassing and you can see that white powder has formed it is better to replace the battery immediately.

A changing bag is another useful edition to your emergency kit. This is a light-tight bag usually made of black opaque cloth with elasticated sleeves to allow the forearms to be inserted. Cameras and jammed or damaged film can be manipulated without any fear of exposure to light. In some cases this may be the only way to prevent wastage of exposed film. Such a bag is essential when unloading infra-red film into the camera in the field.

CARING FOR EXPOSED AND UNEXPOSED PHOTOGRAPHIC MATERIAL

Generally speaking the four factors which can most affect any photographic emulsion are light (and other electro-magnetic radiation) temperature and humidity fluctuations (particularly high extremes) and fungal attacks. The longer that these factors are allowed to act on a photographic emulsion the more likely it is that damage will result.

As regards light and other electro-magnetic radiation, these particular problems can usually be avoided provided that the film is never unwittingly exposed to light or X-rays, and is loaded and unloaded from the camera away from the direct sunlight.

Temperature fluctuations however are a particular problem in mountain regions where high diurnal and nocturnal temperature variations occur. This problem can affect exposed film and is more noticeable with colour than with black and white film.

In many cases all one can do is to keep exposed and unexposed film in some sort of insulated container. Some of the smaller, robust, insulated picnic bags are quite useful for this purpose. However, if you prefer there is a range of open and closed cell foams available from which an insulated container could be made to suit your particular needs.

Above all film should not experience the heat of direct sunlight. It is worth remembering that film often experiences the greatest exposure to temperature fluctuations while still in the camera. Try not to leave the camera in a location which will become especially hot or cold.

High humidity can hasten the deterioration of photographic emulsion and can also encourage the growth of fungi. Until the film is removed from its plastic, foil or metal container it is fairly well protected from this problem. However, once in the camera the film is then able to lose or absorb moisture depending on the humidity in the surrounding air. When taking photographs in humid conditions where exposed film may have to wait a long time (more than two to four weeks) before processing it may be possible to pack the film or cassettes

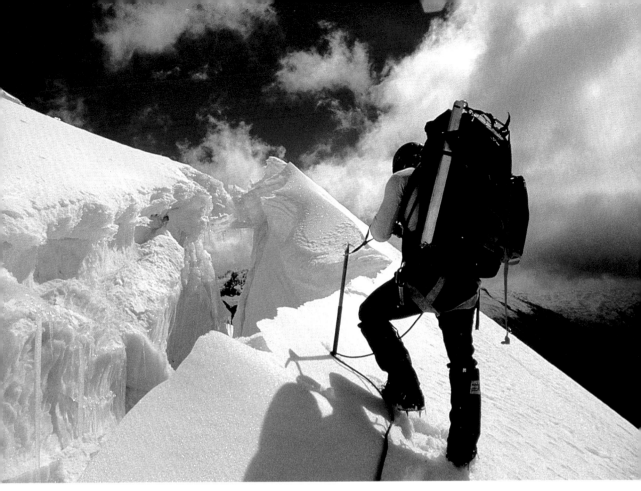

A bergschrund, or large crevasse, at the foot of the North-East face of Artesonraju.' (Olympus OM2, Zuiko 24 mm, Kodachrome 25.)

with a sachet of desiccant for about 24 hours before sealing them in airtight containers. Remember that a mid-humidity of 50 per cent is preferable. So as not to desiccate the emulsion, do not leave the film in the desiccant longer than the recommended time.

Provided that the film is not stored in conditions of high humidity for too long the chances of fungal attack are considerably reduced.

Although the degree of severity of these various hazards is important, the time over which they are allowed to affect the film is also crucial. Provided that the time between shooting and processing is short then many of the conditions which can harm the film are lessened. All film should be processed as soon as possible after shooting and then stored at mid to low humidity and about 20°C.

Details on the use and reconstitution of silica gel are contained in the Appendices at the end of this book.

CHAPTER 4 HOW TO TAKE BETTER MOUNTAIN PHOTOGRAPHS

INTRODUCTION

Mountains have fascinated countless great photographers. The American master of monochrome photography, Ansel Adams, has photographed the mountains of Yosemite National Park and the Sierra Nevada for more than 50 years, documenting every nuance of their changing moods and seasons.

Although good photographs can be taken by chance, being ready in the right place at the right time is an art developed through knowledge, experience and observation. Outstanding photographs are rarely taken by accident. They are produced by a deliberate choice of materials, equipment, exposure, lighting and viewpoint. I have found that few things bring the photographer greater satisfaction than being able to make these choices and produce a pleasing photograph.

This book may not be able to improve the reader's familiarity with the mountain environment but the following sections should help in developing the knowledge and techniques required to take interesting and attractive photographs.

EXPOSURE

Exposure is a term used to denote the amount of light required to strike a film of a given light sensitivity in the process of taking a photograph. The amount of light which reaches the film is determined by (a) the intensity of the light reaching the film and (b) the length of time during which the light is allowed to reach the film. The first is controlled by the aperture and the second by the shutter speed control.

The first step to getting correct exposure is to be aware of the area your light metre is sensing; that is, is it an averaging type, centre weighted or spot meter? And so on. After all, no light meter indicates the 'correct' exposure, only you can decide that. The light meter merely gives an indication of brightness of a certain region of your surroundings.

As indicated in the section on choice of film, colour film, particularly the transparency type, is limited in its ability to render faithfully a large range of variation in brightness. In fact the limit is a range of about four to five stops and with black and white film up to about seven stops. In the former, this means that good shadow and highlight detail will be retained in the photograph if the correct exposure for the shadows is within four to five stops required by highlights. On a bright sunny day as much as 200 times more light can be reflected from an object in the sun, compared to one in the shadows. Therefore you cannot duplicate on film the range of brightness and tonal variation which your eye perceives. One must consciously select which areas must be correctly exposed and which will be over- and under-exposed accordingly.

A memorial statue to the thousands of inhabitants of the village of Yungay in the Peruvian Andes who died when they were avalanched by part of the ice cap of Huascaran Norte (in the background) which cracked off in an earthquake in 1970. The avalanche travelled several miles down a gorge, jumped a hill and landed on the village. Only a handful of people survived.

A wide-angle lens was used in order to make the statue appear to loom over the offending mountain. Deliberate under-exposure was used to darken the sky and add a little extra atmosphere. See also the photograph on p. 45 with respect to exposure using the zone system, pp. 43–5.

(Olympus OM2, Zuiko 24 mm, FP4 and red (25) filter.)

As a general rule colour film will not show shadow detail well and render highlights acceptably. For this reason it is often better to underexpose a shot slightly to capture highlights more successfully. If you lose shadow detail this is much better than the alternative of washed-out highlights.

In the case of black and white photography, it is often better to expose for the shadow detail as this type of film can cope more easily with reproducing highlight detail under these circumstances. Compensation for over-exposure of highlights may then be achieved at the printing or film development stage.

Some filters can alter the relative contrast of certain areas as recorded on the film. These are polarising filters, graduated filters and the yellow, orange and red filters which are used mainly for black and white photography. In particular they can darken sky tones, increase contrast between clouds and sky, or lower the brightness range between sky and foreground. This is discussed in greater detail in this chapter, in the section 'Filters and how to use them'.

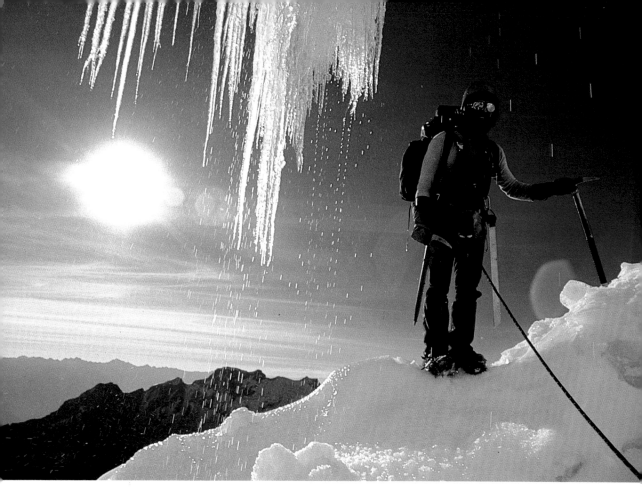

Climber at the lip of a very large crevasse, called a 'bergschrund', on the north face of Huandoy Norte (6395 m/20,980 ft), Peruvian Andes.

It is a wonder this photograph was taken at all under the circumstances. Fifty metres below I had taken a short fall and had become temporarily stuck under the overhang of an ice cliff. Just as I finally got myself over the overhang it began to avalanche on us. I climbed on up the face and reached the safety of this crevasse and then belayed my colleagues. Just as the last climber appeared at the mouth of the crevasse I 'snapped' two quick shots one-handed. We were all exhausted and not a little rattled by our experience but I was pleased I had the commitment and presence of mind to take the photograph.

(Olympus OM2, Zuiko 24 mm, Kodachrome 25.)

In the following sections the notes for guidance apply equally well to using a separate light meter or one integrated into the camera.

If your light meter is of the averaging type you can appreciate the range of brightness in a scene merely by moving it in an arc up and down including more or less ground and sky. The meter needle will indicate a considerable range of possible exposures. If you take the average reading under these circumstances as the correct one this may, in many cases, yield a photograph which is acceptably exposed. However, it still does not take into account whether some elements of the photograph such as a figure in the middle distance will be correctly exposed.

When in a situation where foreground or middle distance detail must be well exposed it pays, where possible, to take a close-up reflected light reading. Alternatively, if your camera has TTL metering the same result can be achieved by metering through a long lens. In some situations even this may not be

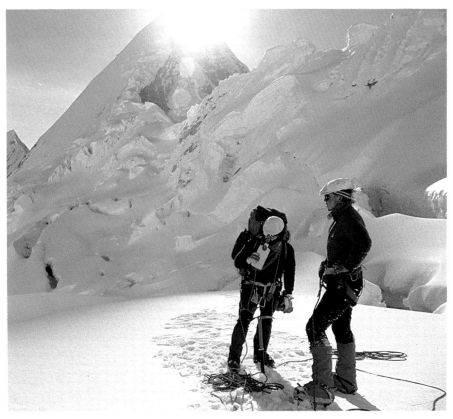

Climbers on the south-west face of Nevada Paron with Nevada Artesonraju in the background. In this back-lit situation only one stop overexposure, based on reflections from the snow, was required. The foreground figures are well lit by light reflected from the snow face in front of them. (Olympus OM2, Zuiko 24 mm, Kodachrome 64.)

possible. This is where an incident light meter reading is invaluable. Generally one can assume that the incident light reaching the photographer is the same as that reaching the object to be photographed. If one points the meter, with the necessary attachment or diffusing cone in place, away from the subject towards the camera position the reading indicates an exposure which will be correct provided that the subject has an 'average' reflectivity.

Alternatively, one can approach to within 2 to 3 m. of the subject and take a reflected light reading. Use that setting when you go back to your chosen camera position or, on some cameras, suitably override the automatic setting.

Average reflectivity is taken as 18 per cent and all light meters are calibrated according to this assumption. Unfortunately in many situations there is no object from which light readings can be taken which has an average reflectivity. This can be overcome by carrying an 18 per cent grey card for reflected light readings or by taking a reading of the skin of the hand. White caucasian skin has a reflectivity which is higher than an 18 per cent grey card but one can compensate by over-exposing by ½ to 1½ stops depending on the contrast of the ambient light. Such compensation is especially important when taking portraits.

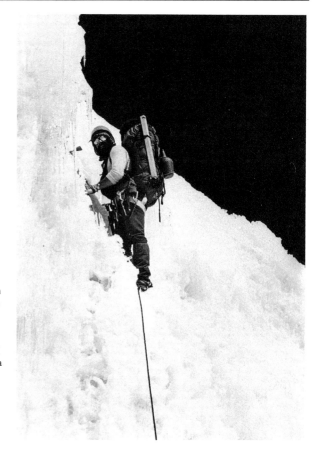

Climber on a steep ice face. In
this situation it is very easy to
under-expose due to the
amount of light which is
reflected from the snow and
ice. Notice that even though I
over-exposed by one stop on a
reflected light reading the sky
is relatively dark. The photo
was taken at almost 5500 m.
(18,044 ft)
(Olympus OM2, Zuiko
50 mm, FP4.)

Different situations which require careful exposure are explained below and
they can then be applied by the photographer to similar situations and used for
guidance or for future reference. The suggested amounts of over-exposure and
under-exposure are given with respect to a colour transparency film and will
vary depending on the type and make of film used and the individual's own
technique. When in doubt about correct exposure for a given situation it is
advisable to bracket your exposures. As experience grows this should become
less necessary.

TAKING PHOTOGRAPHS IN SNOW CONDITIONS

Front lighting. In such a situation a straight forward reflected light reading will
indicate an exposure which would produce an image with a range of tones
whose average is 18 per cent grey. If there was a lot of snow the resulting image
would look quite grey and under-exposed.

To achieve a more natural rendering of the subject tones one may need to
over-expose by one to two stops when using a colour transparency film or even
three stops when using black and white negative film so that the snow appears
brilliant white in the image. This basic exposure should be modified to produce
the appropriate mode and effect the photographer wishes to achieve. Snow does
reflect a considerable amount of light, inflating reflected light meter readings,

and unless one is cautious it is very easy to under-expose in these conditions, thereby losing detail in the shadows and other dark areas.

Back lighting. In this case the amount of reflected light reaching the meter is high and the necessary over-exposure which would be required to bring out detail in darker areas may often be so great as to render the rest of the shot hopelessly over-exposed. Here it may be better to only over-expose by one or two stops to allow reasonable detail in the snow and render any foreground detail or figures as dark tones and silhouettes. Alternatively, to obtain a more dramatic result, one can reduce the exposure to capture more of the snow texture and render highlight detail more adequately. As an alternative one can use fill-in flash. This is dealt with more fully later in the section on, 'How and when to use flash'.

A summary of exposure compensations for photography in snow conditions is given in the Appendices at the end of this book.

LANDSCAPE

Front-lit. Correct exposure depends on how much of the view is composed of highlight; for example, sky, snow and reflections, and how much detail is required in other areas.

If the light is direct and contrasty one will often find that an exposure where the sky is about one to two stops over-exposed and the foreground is about half a stop under-exposed will yield an acceptable shot particularly if a filter is used to darken sky tones.

If the amount of highlight occupies more than about 30 per cent of the picture then a proportionate decrease in exposure may be required depending on the effect which one is trying to achieve. If the sky occupies less than about 30 per cent of the picture more attention should be given to the exposure as indicated for the foreground.

Back-lit. Such scenes often have fewer areas of middle tones and more areas of dark and light tones – they are inherently contrasty. Once again such shots are often taken for their dramatic appeal.

If shooting in colour, then it is better to under-expose and concentrate on rendering good highlights. If shooting in black and white, you must decide whether you wish to retain shadow detail and therefore increase exposure or concentrate on capturing the highlights. A decision must be largely based on which region has the greatest pictorial strength.

PHOTOGRAPHY IN MIST AND CLOUDS

Under these circumstances there is generally a considerable amount of reflected light about and this can over-inflate a meter reading even when the amount of light may appear to be reduced by the filtering effect of the water vapour.

To render the scene 'normally' and capture facial details and the like, over-exposure by one or two stops may be required. The direction of the light in these cases is less important as the effect of mist and cloud makes the light fairly diffuse and non-directional.

Where the direction of the sun can be determined, appropriate changes in exposure may be necessary as indicated in the first example depending on how strongly directional the light is.

A dawn view of the Rhinogs from Bont Newydd, near Ffestiniog in North Wales. This is an example where an orange filter, normally used in monochrome photography, can produce an interesting and colourful result. In this sort of back-lit situation one is often well advised to meter for the highlights especially when shooting in colour. This is probably best achieved by taking an incident light reading and then under-exposing up to one stop.
(Olympus OM2, Zuiko 50 mm, Kodachrome 25, orange (15) filter.)

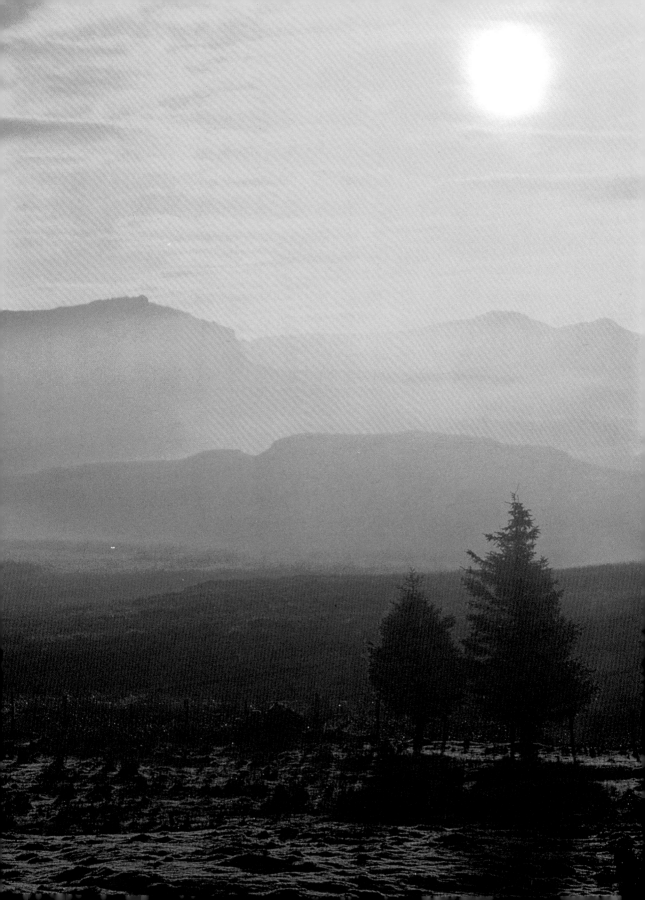

Kilimanjaro seen through mist and giant heather. In this circumstance one should really over-expose, by up to one stop, if it is possible to take a general reflected light reading. These sorts of shots can be very effective but one needs objects in the foreground and middle distance to give a feeling of depth.
(Olympus OM1, Zuiko 24 mm, from a Kodachrome 11 transparency.)

COPING WITH CONTRAST

Example one: subject in shadow. In this case one must increase exposure appropriately so that the subject and not necessarily the dark background is correctly exposed. This may be one to two stops more exposure than indicated. If the remaining lighter area of the picture has good detail and important features such as clouds and distant peaks which give atmosphere it is possible for these to become over-exposed using the above procedure. It must be decided if it is worthwhile losing the detail in these areas to capture foreground or shadow details.

Sometimes the solution to achieving correct exposure of distant highlights is to use fill-in flash to lighten foreground detail. This technique is discussed more fully later.

Example two: subject against a light background such as snow or sky. The method of determining the correct exposure here is a little like that described in the first example in this section. However, the degree of over-exposure required will depend on how light the subject tones are, and how this compares with the brightness of the background. If it is possible, it is a good idea to take a close-up meter reading from the subject; if not, you can obtain a good approximation of the required exposure by metering the light reflected from the back of your hand. Alternatively, you can rely on an incident light reading. Once again you must weigh the importance of gaining shadow detail against losing highlight detail.

Incidentally if you are trying to take a portrait of someone with a very dark complexion under these circumstances it is very easy to underestimate the exposure required to obtain a good rendering of skin tones. Wherever possible try to take close-up meter readings and then work out the most appropriate compromise.

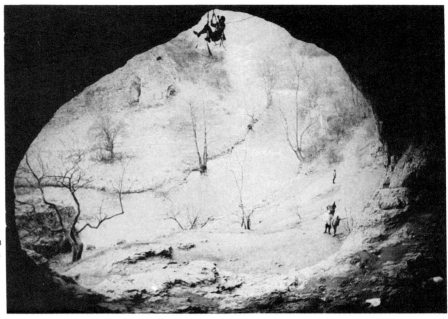

Climber on an artificial route in Dove Hole, Dovedale in the Peak District. Here it was very difficult to determine the most satisfactory exposure. I wanted to obtain some detail at the edges and roof of the cave while over-exposing the outside sufficiently that the dangling climber would be a clear silhouette. I used a 100 mm lens and took a reflected light reading from the edge of the cave (where I wished to retain a little detail). This is a useful technique if you do not own a spot-meter. Then I swapped to a wide-angle lens to take the shot. (Olympus OM2, Zuiko 24 mm, from an Ektachrome 200 transparency.)

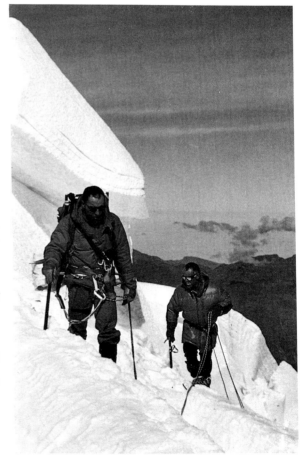

Climbers approaching the summit of Huascaran Sur, Peruvian Andes. If detail is required in the faces or clothes of foreground figures against a very light background like snow it is better to take a reflected light reading off the skin of the hand and over-expose slightly, say a half stop. If there are good reflective surfaces nearby it may be enough to use the reading straight without any compensation because this will tend to throw back a lot of 'fill-in' light on the subject. By doing this one can also preserve more detail and texture in snow. (Olympus OM2, Zuiko 50 mm, FP4.)

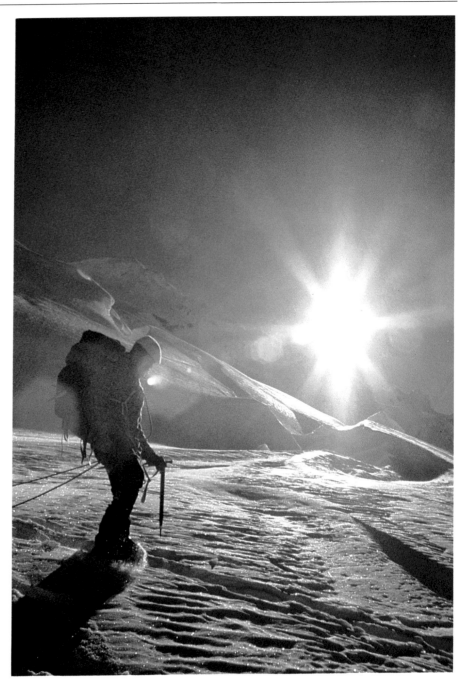

Climber descending the south-west face of Nevada Artesonraju in the Peruvian Andes. Severe under-exposure produced a quite dramatic shot despite the flare. Notice how detail has been preserved in the snow with the figure of the climber becoming silhouetted.
(Olympus OM2, short range zoom, Ektachrome 200.)

SHOOTING INTO THE SUN OR CONTREJOUR

These types of shots can yield dramatic and atmosphere-packed photographs. However, if one is actually shooting directly into the sun the flare which often results can be troublesome or even a little clichéd. In this type of situation it is always a good idea to use a lens hood.

If the sun is to be included in the shot and the photographer wishes to concentrate on retaining highlight detail the meter should be moved until the sun is just out of the angle of acceptance or just out of the field of view. Where the intention is to concentrate on the pattern of highlights the sky can often be metered at the horizon. This may then either be used as the basis for exposure or if other considerations must also be made the photographer can decide on the correct balance of over- and under-exposure using the techniques already learnt. Metering without the sun in view is a good idea because it can drastically over-inflate the reading to the extent that bad under-exposure results.

EXPOSURE BY THE ZONE SYSTEM

This system was developed by the great American landscape photographer, Ansell Adams. Superficially it may appear relatively complicated but even a basic understanding of the underlying principles is a tremendous aid in coping with difficult exposure situations. For the fast moving mountain photographer strict adherence to the system may be impractical. Nevertheless, for the serious photographer it is a very useful guide.

The system applies particularly to monochrome photography and the ability of printing paper to reproduce only a limited range of tonal variation from the base white of the paper to the deepest black. It ensures that the film is given the optimum exposure to record maximum detail throughout the range of brightness of the scene. The complete tonal range is divided into ten zones numbered from zero to nine, each of which is one f-stop different from the adjacent zone; that is, relative to each zone, the one immediately below is twice as bright or reflective and the one immediately above is half as bright or reflective. Middle or 18 per cent grey corresponds to zone five with five darker zones above and four lighter zones below.

Using this system the photographer decides to which zone he judges that each area of the scene before him will be assigned. Suppose, for example, he is only able to take a reflected light reading from a relatively bright object in the foreground which he judges would correspond to zone eight. Therefore, zone five, which requires the 'average' exposure, must receive three stops more light to be correctly reproduced on the film. If the exposure for zone eight was $1/125$ at f8, then the actual exposure for the photograph needs to be $1/125$ at f2.8 or $1/60$ at f4. Likewise when metering for a darker zone an appropriate under-exposure will be required.

If the scene has relatively more areas of brightness than darkness the zones may need to be 'moved' so that zone five will correspond to one of the more average of the bright areas. In a situation where the darker areas are of greatest interest a movement of the zones in the opposite direction is required.

The system is also useful to the colour photographer bearing in mind that colour material can only reproduce about half of the brightness range which can be recorded by black and white film. However, this problem can be overcome if the photographer adjusts his thinking and judgement of brightness values accordingly.

The zone system should be used as a tool and not a pattern for the measurement of exposure. It is particularly useful where areas of considerable

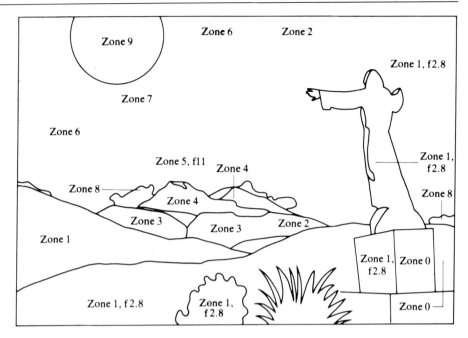

Fig. 1 Distribution of zones based on the photograph on page 33

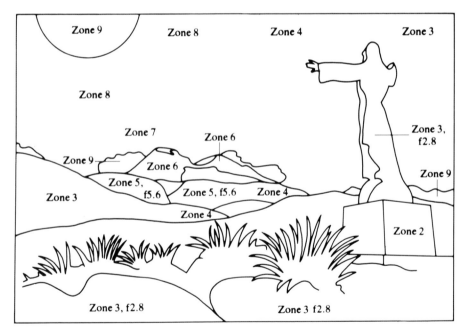

Fig. 2 Distribution of zones based on the photograph on page 45

difference in brightness will be included in the photograph and an average exposure is difficult to judge.

The key to using the zone system is to first visualise the photograph which you intend to create. The effect that I wanted in the photograph on page 33 was a dark, dramatic image with just a little detail visible on the rim of the statue and in the mountain background. Because the statue was white I took a reflected light meter reading from the shaded side which was f2.8, 1/125 of a second. I

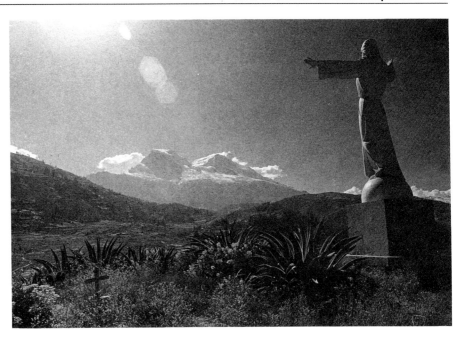

Memorial at Yungay.

decided to make this area correspond to zone one, that is, almost totally black with a minimum of detail visible. This meant that the actual shooting exposure would be four f-stops less, that is f11. (See Fig. 1).

The photograph above was taken without the gross under-exposure of the photograph on p. 33. The exposure was based on the foreground because it was here I wanted to show detail. I decided to make this zone three so that it would be dark but with good detail. The meter reading in this case was again f2.8, $\frac{1}{125}$ of a second. In this case the shooting exposure would be only two f-stops less, that is, f5.6 (See Fig. 2).

The beauty of the system is that having decided which area of the scene will correspond to which zone an exposure meter reading can be taken from a convenient surface. Then the necessary camera settings are calculated with the knowledge that each zone is separated by one f-stop difference in exposure. However, it must be emphasised that to use the system the photographer must first visualise the photograph and then assign the tonal values required to the different areas of the scene.

HOW TO ACHIEVE EFFECTIVE COMPOSITION

There is no one or even several right ways to compose the elements of a photograph. In fact a good composition rests in the eyes of the beholder. The way in which you compose a photograph is as individual as your own fingerprint and represents the unique result of the chemistry between your senses and experience and the environment.

It is important from the outset to dispel any ideas that there are any short cuts or 'golden rules' to good composition. Edward Weston once said that good composition was the strongest way of seeing things. It is misleading to try to pull a photograph apart and then, by looking at the pieces, try to work out why it is good. It is equally misleading to assume that by putting a certain combination of effects or elements into a photograph in a recommended way

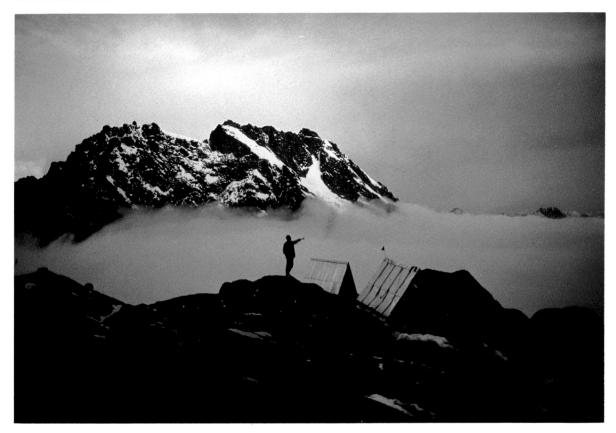

Evening view of the north-west face of Mt Baker from Mt Stanley in the Ruwenzori Mountains in Uganda. Although the effect in this photograph is fairly monochrome the faint tinges of pink and purple, which give this shot much of its atmosphere, indicate that this is a colour photograph. One can make very effective colour photographs which are predominantly just one colour.

There are four layers to this photograph which help to emphasise the impression of depth. The first is the foreground, which is largely featureless except for reflections in the few pools of water, the two huts and the figure. The second is the gulf filled with clouds and the third is the mountain with its streaks and patches of ice and snow. The last is sky, which shows just a little texture.

I included the figure to give some impression of scale and a centre of interest because the surroundings were so bare of detail. However, this bareness and lack of colour helped to communicate the sense of isolation, coldness and atmosphere of this camp in the heart of the 'Mountains of the Moon'.

(Olympus OM1, Zuiko 50 mm, Kodachrome II.)

that you are automatically going to get a good end product. The composition of a photograph really needs to be looked at as a whole. The reason why the subject is broken down into headings such as shape, tone and colour is for convenience, otherwise any discussion would be hopelessly unwieldy and unintelligible.

Nevertheless composition should not be a random process governed by chance but a deliberate decision to capture a moment in a particular way. Therefore guidelines can be given to ensure that the photographer is aware of those things which make up a composition and how they can be used to effect.

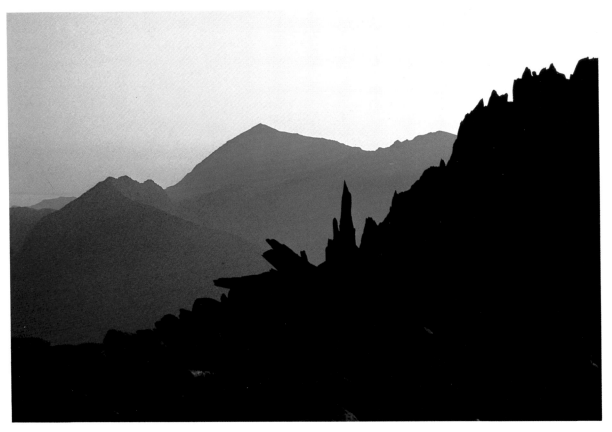

Snowdon and Crib Goch from the Glyders in North Wales. This is an example of choosing film, lens, location and time of day to get a particular effect. For this shot I used photo-micrographic film to get the unusual colour, not a filter. It is a very slow film (ASA 16) and is not meant to be used for general daylight photography because of the magenta cast it produces. I chose this film because it has extremely fine grain and very high contrast which far surpasses Kodachrome 25. I felt the colour and jagged shapes would emphasise the weird and wild nature of this area. I needed the high contrast because I wanted to form silhouettes and semi-silhouettes in the very hazy and diffuse sunlight. A very long focus lens was used to stack the mountain ridges and peaks one behind the other.
(Olympus OM2, 300 mm lens, Kodak Photomicrography film (2483).)

Photographers should realise that within their limitations they are designers with a variety of tools to put together an image which may appeal to themselves and others.

Firstly let us discuss what makes a pleasing or effective photograph. An effective photograph is one which has some effect on the viewer – the more effective the photograph the stronger the viewer's reaction to it. A photograph which provokes little reaction from the viewer is obviously not very effective in those circumstances.

A photograph is taken because something in the original scene impressed the photographer sufficiently to want to record it, and it is natural that the photographer should try to arrange the elements making up the photograph so that they show to advantage and are of interest both to himself and the viewer.

To make or compose a good photograph one needs something to say. This does not come in a blinding flash of inspiration. To say something one has first got to feel or have an emotional response to the subject. Then one must think of ways to make a composition which will say most strongly what one has seen or felt.

If we call whatever it is that the photographer hoped to record or communicate in the photograph its theme, then we can use this as a basis to approach the question of good composition. If the photographer has at least got some idea of why he is taking a particular photograph and what it is that he hopes to communicate he is on the way to communicating his theme. The naive photographer who takes a photograph on impulse without using the available techniques to ensure that his photograph is effective is likely to be disappointed by the result.

Treating photographic composition thematically is not as complex as it sounds. It is simply recognising what has sufficiently impressed you to take the photograph, be it stillness, loneliness, a sense of drama, coldness or warmth. Many of the most effective photographs have generally one theme or at least a main one. However, a theme may be simple or complex without decreasing the effectiveness of the photograph.

The arrangement of the elements of the photograph should reinforce or emphasise the theme of the photograph. This is the key to good composition.

SHAPE, TONE AND COLOUR

Having dispelled some misconceptions about the subject it is important to discuss the vocabulary of composition; that is, the basic essentials with which a composition is created.

The different elements in a photograph have two basic features: shape and tone. Tone is how dark or light a surface appears. Shape is not only the outline of the elements in a photograph but also the extent of different tones and their relationship with others adjacent to it. Colour is the third basic feature and from these, others, such as pattern and texture, are derived.

BALANCE AND IMBALANCE

To some extent good composition is the putting together of shapes, tones and colours in a way that is pleasing to the eye. Sometimes these are arranged to achieve a sense of balance and at other times of imbalance. One may also place points of interest at different positions in the photograph. Very often it is unsettling to the eye to have a composition where there is too much symmetry; for example, where the centre of interest is exactly in the centre of the photograph. It is often more pleasing to put the centre of interest slightly to one side or the other; this may be a tree, a figure in a landscape or anything else. A feeling of balance is often achieved in this way.

DEPTH AND PERSPECTIVE

Depth and perspective are important and one often needs to give an illusion of three-dimensionality to the flat photograph. Items of interest in the foreground, middleground and background can give an illusion of depth and create a more attractive and natural effect. Attention may be drawn to a particular element by placing it on something which links the foreground and background of the

photograph, such as a figure on a path or a stream leading into the photograph. Likewise streams, a line of trees, or a rope can lead the eye through the picture and even create an illusion of depth where points of interest at various depths in the photogra h may be lacking.

Depth and perspective can be further enhanced by the careful control of the depth-of-field, by choice of lens and aperture. By reducing depth-of-field one can make a certain area of a photograph pop out and take the viewer's attention. The longer the focal length of the lens the more reduced the depth-of-field. Likewise the greater the lens aperture the more reduced the depth-of-field. Therefore to show in clear focus certain foreground and middleground details a lens of short focal length and/or small aperture should be chosen.

CONTRAST AND HARMONY

Another compositional tool is the use of different features which contrast or harmonise with each other. One can use areas of similar or different textures or juxtapose areas of widely disparate colours or ones where there is only slight variation.

A composition of bright colours, contrasting tones and jagged shapes can communicate a sense of drama or liveliness. Sombre or harmonising colours such as greens or blues can communicate a sense of mystery, mood, atmosphere or even a sense of foreboding.

SELECTION AND EMPHASIS

Many novices make mistakes in composition because they have not yet developed an awareness of detail. It should be remembered that whereas our sense of sight allows us to concentrate our attention on certain aspects of a scene the photographer must select consciously by excluding or including elements to achieve this effect.

This to a large extent sums up composition for the mountaineer and walker. He only governs the situation at the time of releasing the shutter – he hasn't the freedom of the studio photographer to move the elements of the photograph to suit himself. Above all you should try to emphasise the most important details and keep those which might distract out of the picture by changing the position or angle of the camera. Choosing a lens of greater focal length or waiting until the light changes may help to emphasise chosen elements of the picture and lessen distracting peripheral details.

Generally it is a good practice to adopt a habit of casting your eye around the image in the viewfinder before pressing the shutter button to assess the balance and impact of the photograph and to spot any distracting details which might otherwise be missed. When using an ultra-wide angle lens you may even miss the intrusion of bits of personal clothing and equipment into the picture.

Remember that it is often a good idea to include only one main point or focus of interest in your photograph, or at least to have all others subordinate so that the eye is not confused by many different aspects of the photograph competing for interest. This can be achieved by emphasising one element by making it appear larger, possibly by placing it in the foreground, or if this is not possible by using a long focal length lens which will make it stand out from the background and reduce the depth-of-field. The effect can also be achieved by placing or waiting until less important details are in shadow or by specifically exposing for the centre of interest.

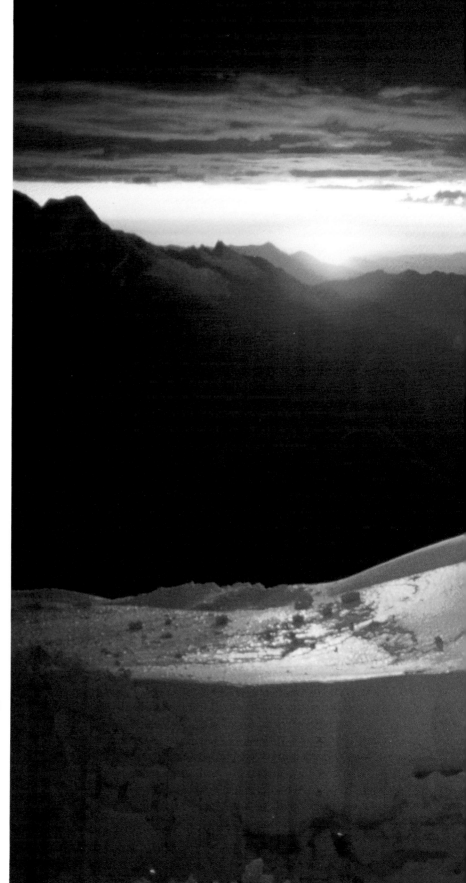

Sunset view after an alpine storm. Other than the red and yellow of the sunset there is very little variety of colour in this shot. However, these bright colours combined with the great variety of tones and shapes, like the ice-mushroom on the right, contribute to the dramatic effect.
(Olympus OM2, short range zoom, Kodachrome 25.)

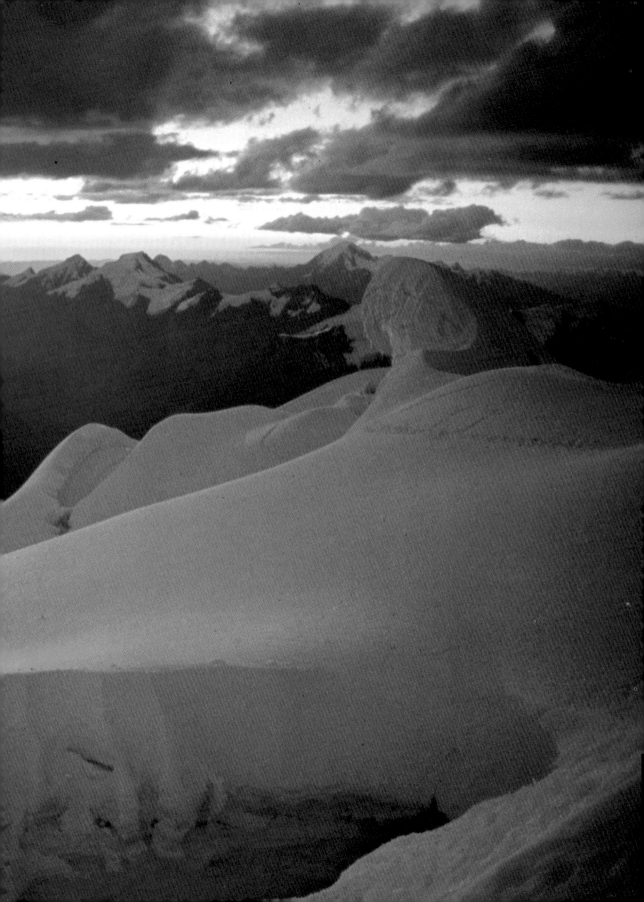

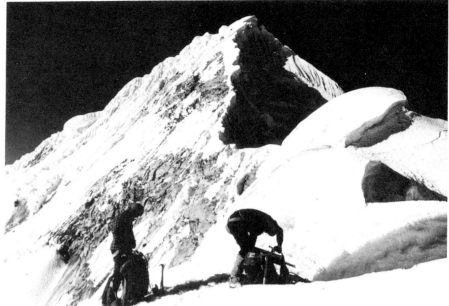

Depth and perspective. This is
an example of the use of a very
wide-angle lens to create a
sense of depth. Although the
apparent steepness of the ridge
has been reduced by using this
lens I could not have shown
the entire summit and its bulk
any other way. The extreme
depth-of-field and strong
side-lighting also contribute to
the overall effect.
(Olympus OM2, Zuiko
24 mm, FP4.)

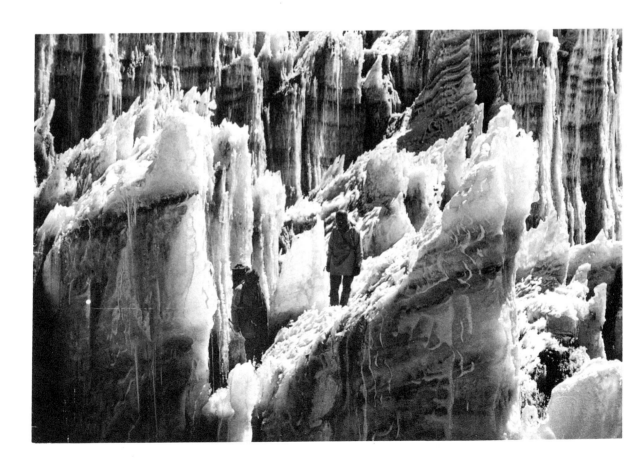

CREATIVITY

It may sound presumptuous to suggest that one person can tell another how to be more creative, but the following advice may help.

Never be afraid to experiment. If you get an idea for a photographic effect, try it, or note it down somewhere for future reference. Also if an idea comes to you while out photographing, take a couple of shots. Occasionally one will work out but many of the experiments will be quite ineffective; even so, you will usually see that although the technique was not quite right in one set of circumstances it can be improved or applied at a more appropriate time. Never get to a stage where you always trust a tried and tested technique exclusively. If one wishes to improve, a little wasted film is a small price to pay for the gradual development and broadening of expertise and experience.

Don't forget that walking and mountaineering are adventure sports and action may often be the key to a successful photograph. Watch the climber carefully and learn to recognise and anticipate the moment when the sense of action is at its highest. This may correspond with the moment of greatest tension but more often the height of action is when most of the tension has been released – for example, when the climber is at maximum extension or at the moment of greatest instability when the individual's posture indicates the inner tension. Too often photographs are taken (and admittedly can only be taken)

Left: Icefall on the summit of Kilimanjaro. This photograph required the figures to give a sense of scale to the fluted ice. The isolation of the figures is what really makes this shot. Had I included the sky or cinders at the bottom of the icefall I feel that this effect would have been diluted. (Olympus OM1, Zuiko 50 mm, from a Kodachrome II transparency.)

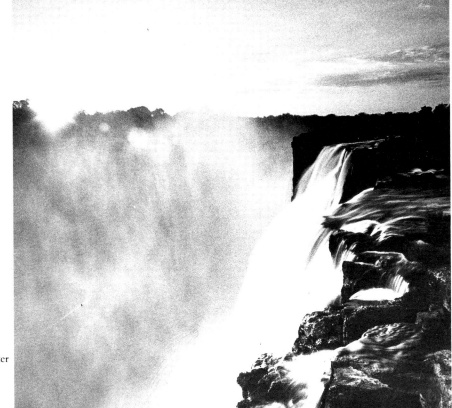

Time exposure of a waterfall. Many creative techniques are quite simple. Photography enables the photographer to capture split seconds or longer intervals of time. A time exposure can transform flowing water into something entirely different in appearance. A 30 second exposure was used and a red filter to boost contrast in the sky. (Olympus OM2N, Zuiko 24 mm, from a Kodachrome 25 transparency.)

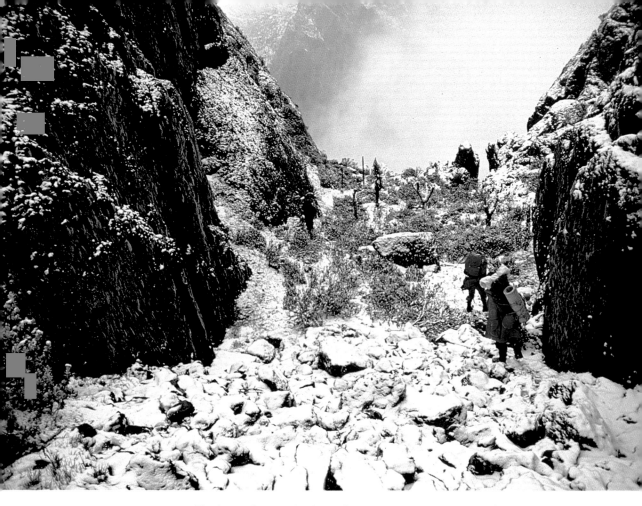

The descent from Mt Stanley in the Ruwenzori Mountains, Uganda. In very overcast or misty conditions it is difficult not to end up with a shot which looks as though it was taken in black and white. This photograph was given the necessary 'lift' by the contrast of the bright clothing of the climbers against the dull surroundings. The mist and confined nature of the gully is sufficient to make this an interesting and moody shot.
(Olympus OM1, Zuiko 50 mm, Kodachrome II.)

when the moment of greatest action or drama has already taken place because the camera has not been to hand at the vital moment or there was a lack of anticipation.

THE USE OF SELECTIVE FOCUS

All lenses have the property that they bring to focus only those points in a plane roughly parallel with the film and a certain distance in front of the lens. Any point in front of, or behind, that plane will be out of focus to an extent depending on several factors:
 (a) how far the point is from the plane of correct focus,
 (b) the focal length of the lens in use,
 (c) the aperture or size of the hole in the diaphragm,
 (d) how close the plane of focus is to the lens.
Depth-of-field is a term used to indicate how far in front and behind the plane

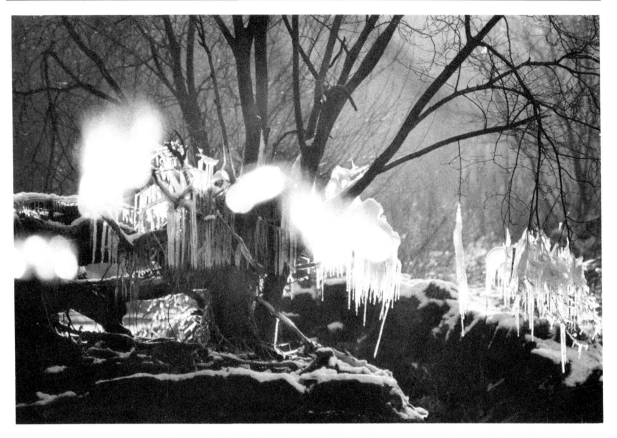

The use of selective focus. The blobs of light which appear to be coming from the icicles hanging on the tree are in fact some more icicles, quite out of focus, just in front of the very long lens I used. The camera position was chosen so that the blobs would coincide with the icicles in the background. Don't forget that selective focus can be used to put the foreground as well as the background out of focus. (Olympus OM2, 300 mm lens, from a Kodachrome 25 transparency.)

of actual focus an image will still appear acceptably sharp. In general, as any of the above four factors increase so the depth-of-field decreases.

These properties can be used for pictorial effect by deliberately ensuring that certain of the elements are in or out of sharp focus. Such a technique can be used, for example, to heighten the impression of depth in a photograph.

A lens with a button which allows manual stop-down of the lens aperture is extremely useful where control or depth-of-field is critical. It allows the photographer to see how much of the scene will be rendered in sharp focus before making an exposure.

FILTERS AND HOW TO USE THEM

FILTERS FOR GENERAL USE

Skylight filters. These filters usually have a slightly pinkish tinge and may be coded as 1A and more recently as 1B. They are designed to meet the

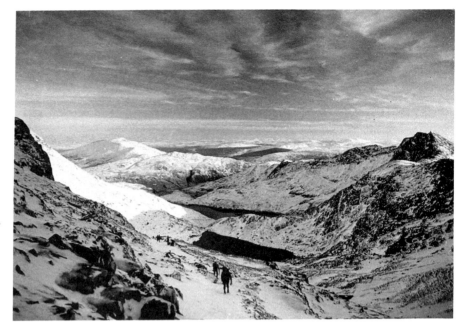

The Zig-Zags and Cwm Glas on Snowdon, North Wales. A polarising filter is just as effective in black and white photography as in colour work, especially in emphasising contrast and texture in cloudy skies. (Olympus OM2N, Zuiko 24 mm, FP4, polarising filter)

requirements for colour photography but can be used generally. They are particularly useful in absorbing the excess ultra-violet light present in mid-day sunlight or at altitude. The excess ultra-violet light causes colour photographs to appear slightly bluish and reduces contrast in colour and black and white photography.

These filters have no noticeable effect on the exposure required and are also invaluable in protecting the delicate and expensive surface of the lens from dust, water and scratches. They may also on occasion absorb any blow that would otherwise shatter your lens. A little money spent replacing a broken Skylight filter is far better than lots of money spent on a new lens.

Top quality filters are made of the same quality of optical glass as a lens and the argument that they degrade image quality is largely nonsense. If the filter becomes too scratched one can simply replace it. They can be fitted to the lens at all times even when near sea level and may be used also for black and white photography. For this reason ultra-violet (UV) absorbing filters made especially for monochrome photography are unnecessary. Furthermore they are not as well suited to colour work as the Skylight filter.

The polarising filter. These filters are particularly useful for reducing the effect of haze, producing more saturated colours and increasing the contrast between sky and clouds. They also reduce the effect of reflections on water and snow surfaces. They work by absorbing that light which has had its plane of polarisation changed during reflection from tiny drops of atmospheric moisture or from a water surface.

Because they absorb some incident light, compensation of about 1⅓ stop over-exposure must be made if the filter does not also cover the light meter.

They are more effective in reducing haze and increasing sky contrast the further from the sun the lens is pointed, reaching a maximum when pointed at 90° to the direction of the sunlight. As the lens is pointed nearer the sun the effect of the filter becomes reduced.

These filters are very easy to use in conjunction with an SLR camera. One simply looks through the viewfinder and rotates the filter until the desired amount of contrast is achieved. When using a non-reflex camera one can hold the filter in front of the eye in the same direction as the photograph will be taken. The filter is then rotated until the desired effect is achieved. On the barrel of the filter will be an engraved mark – note its position and place the filter over the lens in the same orientation. Alternatively, in the case of some of these filters if the engraved mark is turned so that it is directed towards the sun this often marks the approximate orientation for maximum polarisation.

In many makes of camera which have TTL metering the meter will not indicate the correct exposure when a linear polarising filter is fitted to the lens. This problem can be overcome by using a circular polarising filter. Polarising filters are suitable for use with colour as well as black and white film.

FILTERS FOR BLACK AND WHITE PHOTOGRAPHY

Yellow, orange and red filters. These filters absorb the shorter wave lengths of light, in particular blue. Yellow is the weakest, followed by orange, and red, the strongest in this effect. They can therefore increase the contrast between clouds and sky by making the sky appear darker. They are also very effective in reducing the effect of haze.

Although intended for use with black and white films they can be used for creative effect with colour films. It should be remembered that some exposure compensation is required as they absorb incident light. These filters are available in a variety of densities and the exact compensation required is usually indicated in the instructions packed with the filter.

This type of filter is particularly of use when taking landscape photographs where the effect of haze reduces contrast and clarity, especially nearer the horizon. The effect of the most commonly used filters is summarised in Table 1.

SPECIAL EFFECTS FILTERS

Graduated filters. These are filters where the toning, which may be coloured or of a neutral density, extends over a portion of the filter. They allow the photographer to be selective in darkening or tinting one half of the view, which is particularly useful when trying to darken sky tones. They can also be used for creative effects by darkening or tinting foreground. The effect of these filters is generally more noticeable the more one stops down. If the camera has a depth-of-field preview button it may be as well to use this to examine what the final effect will be. Care must be taken when using ultra-wide lenses because small apertures can cause a vignetting effect or an arc of darkening above the area concerned.

Star-burst. This dramatic name gives some indication of its effect and they can be very effective if not over-used. They are made from a plane glass element engraved with parallel lines set at right angles giving a chequered appearance. Point sources of light are rendered with a star appearance – the number of rays depends on the number of sets of parallel engraved lines.

They can be used to give dramatic pictorial effects of the sun, moon and stars or areas of bright reflections on ice, snow or water.

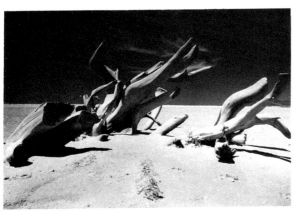

Half tinted filters. A combination of a polarising filter and a neutral density graduated filter was used in this shot to completely darken the sky in the upper part of the picture. I wanted to emphasise the sculptural quality of these dried and half buried branches. A wide-angle lens was used which arched the darkening effect of the tinted filter over the branches. However, sometimes the photographer may be caught unaware by this effect unless he stops down and previews the effect before making the exposure.
(Olympus OM1, Zuiko 24 mm, FP4, Hoyarex polarising and graduated neutral grey filter.)

Star-burst or cross screen filters. A shot of a familiar subject, a bracken frond, from an unusual angle.
(Olympus OM1, Zuiko 24 mm, FP4, Hoyarex polarising and Star 4 filters.)

TABLE 1. Filters for black and white photography and their effect in daylight

Filter	Exposure compensation	Effect
Yellow (K2 or No. 8)	+ 1 stop	Slight darkening of blue sky. Gives a more natural range of tones to sky and distant landscapes, including snow and foliage. Good for outdoor portraits and can be kept on lens permanently.
Yellow-Green (XO or No. 11)	+ 2 stops	Slight lightening of foliage and darkening of reds. Good for outdoor portraits.
Orange (G or No. 15)	+ 1⅓ stops	Darkens blue sky and water surfaces. Reduces effects of haze. Slightly darkens foliage and enhances textures in snow. Produces more marked effects than the yellow filter.
Red (A or No. 25)	+ 3 stops	Considerably darkens sky tones – produces dramatic photographs. Reduces apparent haze. Greatly enhances texture in snow and landscapes. Lightens the tones of red or orange in scene. Can produce spectacular, almost unreal, landscapes when a stormy sky is included. Darkens water surfaces if reflecting blue sky.

Filter	Exposure compensation	Effect
Blue (No. 47)	+ 2⅔ stops	Increases the effect of apparent haze. Lightens blue surfaces such as sky and water.
Polarising	+ 1⅓ stops	Reduces effect of haze and darkens blue skies. Increases contrast between sky and clouds and reduces reflection from water surfaces. Has the greatest effect when camera pointed at right angles to direction of sunlight. Good for general use.

There are many more coloured filters for black and white photography than those listed above. Each has a specific exposure compensation requirement. Exposure compensation can vary depending on the lighting and type of film in use. These figures are mainly relevant to cameras not equipped with TTL metering as this type of meter will automatically compensate for any light absorbed by the filter.

HOW AND WHEN TO USE FLASH

Electronic flash guns are becoming more powerful but lighter and more compact and are therefore increasingly practicable propositions for the mountaineer, walker and climber. They can be used to show more detail particularly on a foreground figure or object where the sun is providing strong back or side lighting. It is also particularly useful where the complexion or object is naturally dark and could easily be under-exposed.

Some care and understanding is required to work out the correct exposure when using a combination of natural and artificial lighting. With SLR cameras the fastest shutter speeds which will synchronise with electronic flash are usually ¹⁄₆₀ to ¹⁄₂₅₀ of a second. Therefore all exposure settings for the background must be made at this or a lower shutter speed. Cameras with leaf-blade shutters will synchronise with electronic flash at all shutter speeds which gives greater flexibility when calculating a suitable exposure combination.

Having decided the appropriate shutter speed, determine, using the normal procedure, what aperture is required to give a correct exposure for the background. You may even decide to under- or over-expose. Under-exposure by one or two stops would be acceptable if the scene was strongly back-lit. Now work out how far the object is which is to be lit with flash. This is easily done if the camera is an SLR or has a rangefinder, otherwise you will have to estimate the distance. Allowing for the speed of the film you are using, the table on the side of your flash gun will indicate the correct aperture for that distance. If the flash gun has a number of manual settings it may be possible to reduce the power of the gun until this allows you to use an aperture which will also allow the correct exposure required for the background. If the flash gun does not have this facility the distance between the object and the flash may have to be increased or decreased until the aperture required for correct exposure by flash is the same as that required for the natural lighting of the background.

Another way to work out the correct exposure, and this is particularly useful when using flash bulbs, is by using the guide number of the flash. Guide numbers indicate the power of the flash gun and for a particular film speed a gun with a higher guide number is a more powerful light source. If you know what aperture is required to correctly expose the background by natural light simply divide this into the guide number of the flash; this will indicate the required

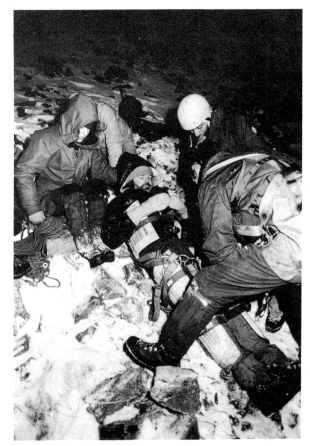

Climbing accident in Scotland.
A compact flash gun was
essential to photograph the
emergency evacuation of an
injured climber by an RAF
search and rescue helicopter
crew.
(Olympus OM2, Zuiko
24 mm, Auto Quick 310 flash.)

distance between the flash and the object to achieve correct exposure. The guide number for a flash gun is usually stated in the instruction book with respect to a particular film speed.

In a more straightforward situation where the flash gun is to be the only source of lighting divide the distance between the flash and the object to be photographed into the guide number and this will indicate the correct aperture to be used. The formulae for guide number use are as follows:

Guide number = Aperture × Distance (between flash and object)

Therefore: Aperture = Guide number ÷ Distance,

and Distance = Guide number ÷ Aperture

The operation of electronic flash guns is made much more simple where the gun is automatic, in other words where the gun has its own exposure meter which shuts off the flash once the object has received sufficient illumination. Nevertheless, some automatic guns are more limited than others and a knowledge of the above techniques is very worthwhile.

It is quite clear that some complications can be encountered using flash, but the most flexible arrangement is generally found by using as powerful a flash as

possible and which has some way of controlling the strength of the flash provided.

NATURE PHOTOGRAPHY

Very good photographs of natural history subjects can be taken without specialist equipment such as macro lenses, bellows, ring flash and extremely long focus lenses. A few minor additions to the range of lenses and equipment that might be used by the lightweight photographer are all that are needed initially. Obviously as you aim higher and your subjects become more elusive or inaccessible your equipment will have to become more specialised. This section is meant to serve as an introduction to the subject for the photographer who may not previously have had experience in this field.

CLOSE-UP PHOTOGRAPHY

Good close-up photographs can be taken using ordinary lenses equipped with a supplementary lens attachment which is screwed on to the front like a filter. Alternatively, an extension tube can be connected between the lens and camera body which also increases the effective magnification of the lens. The latter, in common with bellows, teleconverters and other such devices, have the disadvantage that they reduce the effective aperture of the lens. The former requires no exposure compensation, as it does not reduce the amount of light reaching the film. This means that faster shutter speeds can be used and the viewfinder is brighter for accurate focusing. Because these lenses are not designed to work at such close distances definition is improved in both cases by stopping-down. Supplementary lenses generally yield the best definition in the centre with increasing fall-off towards the edge of the picture. As depth-of-field is generally shallow in close-up photography it is an advantage to stop-down as much as possible. My personal feeling is that the supplementary lens is more convenient to use than the extension tube, as well as being more compact. However, extension tubes can be used with proper macro lenses to yield top quality close-up photographs. One way to overcome the loss of light which accompanies the use of extension tubes is by using flash. In these circumstances some experience is required to get exact exposures unless one uses an electronic flash which can be controlled by the camera's TTL metering system.

In order to stop-down a lens it becomes necessary to choose slower shutter speeds. To prevent camera shake a tripod is almost a necessity. It is difficult enough when the subject is moving but if the camera is moving as well blurred pictures are the usual consequence. A tripod is also essential to enable accurate focusing because depth-of-field is usually so limited. Any camera movement could yield ill-defined pictures.

For this type of work the most useful tripods are designed to allow the camera to be brought down very nearly to ground level. This can be achieved by reversing the central column. In some cases the tripod's legs can be splayed out horizontally, allowing it to be placed squarely on the ground which is a very stable arrangement especially in high winds.

Wind is a constant source of annoyance when trying to photograph flowers and plants. It seems to be only in the most exceptional circumstances that there is just a light breeze. The obvious solution is to shoot between gusts or to find a specimen in a more sheltered location. Of course this cannot always be achieved. Sometimes an improvised windbreak is the only solution. A rucksack

Close-up photograph of a red
campion. A long focus lens
equipped with a close-up
supplementary lens screwed
into the filter threads was used
for this shot. The camera
position was chosen so that the
fine hairs on the stalk and
sepals stood out against the
dull background.
(Olympus OM2, Zuiko
100 mm, FP4, close-up +2
dioptre supplementary lens.)

or a rock stood on end, even another companion can be used. It is important
that the windbreak is carefully positioned so as not to throw a shadow on the
subject. Anyone particularly interested in mountain flora may like to use a clear
plastic screen which can be bent into a cylinder with a small hole cut in one side
to allow entry of the lens.

Small animals, insects and plants are best photographed against a fairly
sombre or unobtrusive background. This can be achieved by altering the camera
angle or by choosing a subject which is in a better position. The limited depth-
of-field inherent in close-up photography generally means that the background
will be out of focus. However, the actual shooting aperture must be chosen
carefully to give just the right effect. In these situations a stop-down preview
button on the lens is especially useful to ensure that the right depth-of-field and
sharpness is achieved.

If the lighting is generally dull or one wishes to highlight the subject one can
use a reflector. For this purpose a compact plane or concave mirror is ideal.
Alternatively if this light is too harsh a white card, stiff card covered with
aluminium foil, or a fabric reflector of the type used in outdoor portraiture is
useful. Once again flash can be used but a little experimentation is required to
work out how to get good exposures. Generally, it is advisable to shoot a few
test rolls.

PHOTOGRAPHING LARGE ANIMALS

For this a long lens is highly recommended. I have found a 300 mm focal length to be a good compromise, offering a sufficiently narrow angle of view without being too heavy, expensive or limited in maximum aperture. If you wish to keep bulk to a minimum you could consider a mirror or catadioptric lens. These lenses use curved mirrors instead of light-refracting lenses and give a similar narrow angle of view but are only about one half of the total length of a conventional long focus lens. Some are very robust but they can be expensive, and often have a maximum aperture no larger than f8. Out-of-focus highlights often appear as distracting light doughnut shapes on photographs where mirror lenses have been used.

The best time of day to photograph the larger mountain mammals is very early in the morning just after dawn, or very late in the afternoon. At these times animals which have been invisible during the day seem suddenly to spring into view. Once in the Sierra Nevada in Spain I was suffering increasing frustration from the apparent lack of wildlife. The nearest I had got to a deer was about 800 m (870 yds). However, one late evening while climbing the flank of Mulacen, deer seemed to be feeding everywhere and allowed me to approach much closer than they had in the daylight hours.

THE IMPORTANCE OF PHOTOGRAPHIC RECORDS AND HOW TO KEEP THEM

The ability to take good photographs comes with experience, which is only valuable if you can learn from your past mistakes. However, if you have kept no record of the light conditions, time of day and so on prevailing at the time that the photograph was taken you will find it difficult to improve next time.

Keeping accurate, relevant notes and records can be a great problem and sometimes is obviously impossible, but it is worthwhile keeping records some of the time. The amount of detail recorded should be relevant and sufficient but should not be too time consuming.

The following is meant as a guide to record keeping, to be modified to suit the individual's needs and situation. It is suggested that a note of the focal length of the lens, the shooting aperture, shutter speed, time of day (and possibly month of year) and a short note of the orientation of the camera with respect to the sun and the general quality of the light will make a relevant and useful record.

A small notebook can be set out as follows:

Shot no.	Lens	Aperture	Shutter speed	Time	Angle to the sun	General quality of light
•						
•						
•						
9	35 mm	f8	$\frac{1}{125}$	1400 April, 80	4 o'clock	Little cloud, hard shadows

With the current miniaturisation of many accessories a small tape recorder (some are pocket size) may be considered an obvious and much more convenient way of keeping records. But a little experience will quickly reveal that

such records may often be of little use unless a consistent format is used for categorising and recording details. It is therefore better to try to record the details in much the same way as one would on paper, preferably keeping to a consistent order and number of details. Provided that this is possible in less than ideal conditions there is little doubt that a pocket tape recorder is the most convenient means of recording photographic data.

It is surprising how quickly details are forgotten, so it is wise to make a record during holidays and trips abroad of ideas, alterations or lessons learnt about photography in the mountains. Mountain photography does require special knowledge, experience and skill and it is only sensible to adopt a systematic approach to the learning process as early as possible.

TAKING RECORD PHOTOGRAPHS OF CRAGS AND CLIMBS

Photographs are sometimes required for record purposes – e.g. to show cliff or mountain features or the routes on them. If you take a photograph from immediately below a crag much detail and scale will be lost due to the foreshortening effect produced by angling the camera upwards. This can be further exaggerated if a short focus or wide-angle lens is used.

The best way to get satisfactory photographs is to keep the perspective as narrow as possible by positioning the camera a reasonable distance away and using a long focus lens. You should also try to have the camera as near to the same mid-height level as is practicable. In many cases this can be achieved by going to the opposite side of the valley or even to a nearby mountain. Some of the most impressive movie and still photography of mountains has been done from airy perches using very long lenses on peaks some distance from the action.

Where the crag or peak is particularly isolated photographs may have to be taken from as far away as can be managed, keeping the camera angle as much below 30° to the horizon as possible. If this still does not yield the results required or cannot be managed – and the situation warrants it – you can always consider aerial photography. This topic is discussed briefly in the next section.

Of course one may aim at producing a distorted photograph. A low or high camera angle will exaggerate the features of the crag in a way which can be usefully exploited. A medium to long focus lens will tend to concentrate interest depending on the depth-of-field. Wide-angle lenses must be used with caution because a low-angled shot will usually diminish the apparent angle of the face. However, a high-angled shot, especially if taken from very near the crag, may make it look much steeper and exposed than in reality.

The other important factor in taking good pictures is to have the light falling at the correct angle to highlight surface features. Often the best time to achieve this effect is shortly after sunrise or a little before sunset. When the sun is low in the sky it highlights cracks and features at an angle to it; these are largely lost once the sun is high. In some cases only morning or afternoon will give the correct light due to the direction of the face relative to the path of the sun. Occasionally it may be sufficient to consult a map to find out which half of the day will yield the best results; but there are times when there may be no alternative but to wait until the light is just right. This decision depends purely on individual taste; the mood and appearance of a rock or ice face will appear most pleasing to a variety of people at different times of the day. However, for the colour photographer the warm, contrasty light of the early and late hours of the day can make for particularly dramatic and beautiful photographs.

Record photographs of crags and climbs.

After a black and white print had been made the route was marked on using a Rotring pen and white ink. A 50 mm lens was used for the shot. This was a 1000 feet route on Nyabubuya, a peak on Mt Stanley, in the Ruwenzori, Uganda.

AERIAL PHOTOGRAPHY

Although aerial photography is a specialist field in itself, nevertheless it may be useful for the mountain photographer to be ready and able to take aerial shots, if necessary.

Atmospheric conditions can largely make or break your attempts to get good photographs. Haze is a major problem and in countries like the UK the best time of year is during the months of April and May before the air has become laden with dust and water vapour. Still air is most likely to be hazy and a light breeze can clear the atmosphere.

Whether shooting in colour or black and white, ultra-violet absorbing filters are a must. When shooting in colour a polarising filter or Skylight filter helps. the former gives more saturated colours and emphasises the contrast between sky and clouds. It can also reduce the reflection from lakes and rivers; the filter must be rotated to achieve the desired degree of polarisation. An orange or red filter has the same effect of increasing the contrast in the sky and penetrating haze when shooting in black and white.

Time of day is another major determining factor in the success of aerial photography. In the morning or afternoon when the sun strikes the land at an

acute angle the resulting shadows show surface contours and features most clearly. When the sun is directly overhead the light is often flat and many of the surface features are lost.

Light aircraft with high wings are best suited to this type of work because the field of view is less impeded. Nevertheless, one should be careful when using wide-angle lenses; and because depth-of-field is not usually a problem the maximum shutter speed should be used. Obviously this becomes more important when using longer lenses which could be adversely affected by vibration.

Vibration is often a great problem when photographing from helicopters. It is best to hold the camera as steadily as possible against your body rather than try to gain support from the inside of the aircraft, which can transmit shake to the camera. Once again, when using wide-angle lenses be very wary about the rotor tips, which, although not visible to the eye, may appear frozen in view in the resulting photographs. It is also advisable to be careful that heat haze from low-placed jet exhausts does not intrude in your shots.

Wherever possible avoid shooting through glass: either remove a door or shoot through an open window. Besides the fact that curved glass can cause distortion the zone toughening of aircraft windows and canopies polarises transmitted light which may appear as dark blotches when using a polarising filter. Remember that the slipstream could be considerable! Needless to say, you should always use a neck strap and have any other equipment not in use well secured.

Exposure can be difficult to judge in these circumstances; it is better to use an incident light reading. It is also important before you start the flight to make sure that the pilot is well briefed about what you wish to accomplish. Once in the air communication may be nearly impossible especially in a noisy aircraft.

COMMON PHOTOGRAPHIC PROBLEMS AND HOW TO OVERCOME THEM

Discovering a fault or error in one's photographs can be a cause of stunning disappointment, especially if the shot is unrepeatable. Nevertheless it is essential that one discovers the cause of the mistake so that, hopefully, it can be prevented in future. This is a baffling and disturbing pursuit but it can also be quite rewarding in terms of the increased appreciation and awareness of the capabilities of photographic material and equipment. One can also gather a knowledge of techniques and effects which despite being a mistake in one context can be used creatively in the future.

The tables on pages 67–8 list some common faults, how they can be recognised and the suggested remedy.

Most of the common problems can be avoided by exercising reasonable care and following a few sensible guidelines, such as always loading and unloading film out of direct sunlight; often it is sufficient to do this in the shadow of one's own body.

Check that the film rolls squarely on to the take-up spool before closing the camera back. Wind on until the leader has just wound on to itself, trapping the free end on to the spool. Try to establish a consistent technique for unloading and loading film. After closing the camera back watch the rewind spool when winding on to see if the film is paying out normally. Always wind on two or three frames so that any fogged film has passed on to the take-up spool.

When a problem appears consistently beware of possible equipment failure. Light meters and camera mechanisms do break down. Very often one is

TABLE 2. Blurred and unsharp negatives and transparencies

Appearance	Cause	Remedy
General lack of sharpness, possible haze around highlights	Dirty or greasy lens or filter	Regularly check and clean lens and filters. Remove grease, etc. with lens cleaning fluid using lens cloth or tissue
General blurring at all distances with some streaking especially of areas closer to camera	Camera-shake	Use faster shutter speed or tripod. Squeeze rather than jerk shutter
General lack of sharpness; some distances may be sharp	Incorrect focus	Incorrect distance set when focusing or range-finder or focusing fault
Lack of depth of sharp focus	Aperture too large or too close to subject	Stop-down more and alter shutter speed appropriately. Move further from subject

TABLE 3. Marks on negatives or transparencies

Appearance	Cause	Remedy
Parallel scratches or 'tramlines'	Grit, etc. in path of film transport	Clean and dust camera regularly
Crescent shaped mark. Black on negatives and clear or bluish on transparencies	Film kinked or buckled prior to processing	Greater care in handling and loading film into spirals required or change laboratory
'Specks, clear on negatives or black on transparencies	Dust on film or in camera preventing light reaching part of film	Clean camera regularly
Branched pattern of marks, light on transparencies, dark on negatives	Flash of static electricity	Rewind film more slowly, particularly in dry conditions
Hexagonal areas on film, black on negatives, coloured on transparencies	Shooting directly into sun and due to internal reflections of light in lens, ie flare	Either avoid shooting into sun, use smaller aperture, or partially obscure sun with edge of cloud or other object
Blotches or bands dark on negatives, coloured on transparencies	Light leaking on to film or excess flare	Load film in subdued light, check light-tightness of camera

TABLE 4. Problems with colour photography

Appearance	Cause	Remedy
Poor colour rendition, greenish and lack of density at film edges	Old or badly stored film	Avoid outdated film. Store film in recommended conditions
Colours too warm	Photo taken at dawn or sunset	Often yields dramatic photos, can be corrected by light blue filter or use flash
Colours too cold	UV or haze giving blue rendition. Artificial light film used in daylight without correcting filter	Use UV or Skylight filter For a stronger warming effect use an 81, 81c or similar filter.
Sky too light or hazy, lack of contrast between sky and clouds	Light reflected from sky haze too strongly recorded by film	Use polarising filter

TABLE 5. Problems with black and white photography

Appearance	Cause	Remedy
Sky tones too light or lack of contrast between sky and clouds	Film too sensitive to blue, hence over-exposed.	Use polarising filter; yellow, orange, and red give increasing contrast

TABLE 6. General exposure problems

Appearance	Cause	Remedy
Transparencies generally too light or negatives too dark	Possible over-exposure	Decrease exposure; if problem consistent check light meter or film speed setting. Possibly a camera or meter fault; may require professional check
Transparencies generally too dark or negatives too light	Possible under-exposure	Increase exposure; if a consistent problem have camera or meter professionally checked

inclined to consider equipment as infallible and to blame oneself for the problems which arise. One photographer went for a long time wondering why his photographs were always out of focus, thinking that his ability to judge distance with his viewfinder was at fault. Later he disovered that the threads on

the focusing control had frozen and stripped. The camera had not been focusing for the past eighteen months!

Always keep lenses and cameras clear and free of dust. Use aerosol blowers to remove dust and particles of emulsion. These also save having to touch delicate lens surfaces unnecessarily.

Try not to breathe on to viewfinder and lens surfaces in cold weather. The water can get between cemented elements and freeze or encourage the growth of fungus.

If there are film exposure problems check if the lettering on the film edge is distinct. If it is, blame exposure rather than processing error.

For the home processor many problems can occur whose correction is outside the scope of this book, but see the Appendices where some suitable books are recommended.

CHAPTER 5 SPECIAL PREPARATIONS AND PRECAUTIONS

PLANNING FOR LONG TRIPS AND EXPEDITIONS

There are four points to consider when selecting equipment and materials for use on long trips; you must be quite clear about your photographic aspirations and intentions; the suitability of your equipment to the nature of the physical environment; the financial limitations; and what you can personally carry in the way of photographic equipment.

This subject has already been discussed briefly in Chapter 1, but it is worth emphasising again some of the more important aspects. It is very difficult to look into the distant future for guidelines with which to make judgements regarding present actions. You may not be completely sure how you want to use your photographs in the future but a little thought at this stage may help you to become more purposeful in your approach. Choice of film stock will depend on whether the photographs are purely for personal record purposes, illustrated magazine articles or slide shows. If the area you are visiting is inhabited there may be interesting cultural life to document. For wildlife photography you may need quite specialist equipment. The lightweight mountaineer has to consider carefully the question of compact, easy to operate, extremely robust cameras and accessories.

EQUIPMENT SUITABILITY AND SELECTION

The mountain environment can be hostile and rough on both the photographer and his gear. If you are in the position of choosing equipment for the first time or upgrading from an older system you would be well advised to consider some of the cameras which have recently appeared on the market and which have been specifically designed to better tolerate extremes of temperature. Some of these have gaskets and 'O' rings fitted to prevent or minimise the entry of dust and moisture.

Automatic cameras which are totally reliant on battery power to operate the shutter and other vital functions may be a liability. A manual camera with a mechanical shutter may be more reliable in extreme cold where battery failure would paralyse the former. If you can afford it, a very useful combination is the convenience of an auto/manual exposure camera body and a standby manual camera body.

Avoid the folly of taking cameras and accessories on an important trip if you have not used them and seen the results at least once. There is always the possibility that there could be a manufacturing fault or you may be unaware of some subtle idiosyncracy of operation. Giving new gear a 'dry run' is not enough. Use some film and you will at least know that you have taken every reasonable measure to ensure that your photography will go according to plan.

Ice flows in a frozen stream in the Cairngorms, Scotland. When one works in freezing conditions it is important to be aware of the pitfalls. If you drop a camera in the snow (it does happen!) clean the snow off with a dry lens cloth or tissue. Don't breathe on the camera or lens; the condensation could freeze snow crystals in place and coat the lens and body with a thin film of ice. This can cause moving parts to seize and when the ice melts it can seep into the camera and cause short circuits and corrosion.
(Olympous OM2, Zuiko 24 mm lens, Kodachrome 25.)

If you wish to document the lives of mountain people you will need at least one lens of between 85 mm and 200 mm focal length for portraits. The best choices are probably a 135 mm lens or an equivalent zoom lens, but a 100 mm lens is often as useful as well as being lighter and more compact. In poor light you may well need an aperture of f2.8, not always available on a zoom lens, or fast film.

A wide angle lens, say of 24 mm to 35 mm focal length, is ideal for photography inside cramped huts and other indoor shots. Interesting portraits can also be taken on wide angle lens but care must be taken to avoid too much distracting distortion. These lenses are also ideal for general use.

At least one long focus lens of 200 mm or longer is well suited to isolating foreground details from a distracting background in addition to yielding concentrating landscape photographs.

If you intend to do any amount of serious wildlife photography it would be wise to choose a lightweight telephoto lens of 300 mm or thereabouts. For

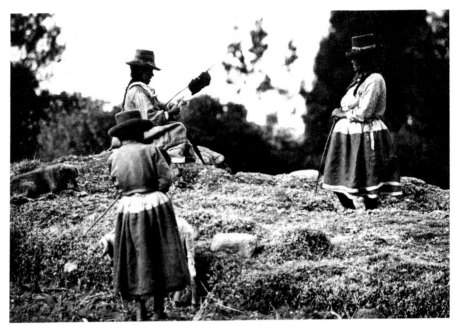

Quechua women in the Peruvian Andes. Despite trying to be tactful on a number of occasions when photographing women and children in the Andes I had been on the receiving end of a number of very hard rocks. So for this shot I used a long lens very surreptitiously. (Olympus OM2, 300 mm lens, FP4.)

photographing birds, longer lenses are generally required. 500 mm catadioptric or mirror lenses could be considered a reasonable choice for this purpose because they are generally smaller and lighter than conventional lens designs, but they do have limited maximum apertures.

Supplementary lenses will allow close-up photography without the bulk of lens extension tubes and can be added or taken off without removing the lens. They also do not reduce the working aperture of the lens. This means that higher shutter speeds can be used and the viewfinder is generally brighter, allowing easier focusing. For really critical work a specially designed macro lens is required.

Tripods can be awkward and easily damaged. Only take one if you intend using long focus lenses, taking time exposures or doing a lot of close-up photography. Remember that it may be possible to use a minipod or a clamp device which can be attached to other solid supports.

Serious consideration should be given to 'dedicated' flash guns which utilise the cameras's own TTL metering system to control the duration of the flash. They are especially useful for close-up work and when using lenses at the extremes of the range of focal lengths. A flash gun with a minimum guide number of 80 feet ISO 100 is advisable unless you have more specific needs.

Often one of the biggest problems is deciding how much film to take. There is no more desolate feeling than knowing that you are running low on film when only halfway through a trip. Try to estimate how much film you might shoot each day assuming that the going was good and then round-up the figure as generously as possible. It is also important to keep the variety of film to the absolute minimum. Try to shoot just one type of colour or black and white film. Choose the lowest film speed rating you think you can safely get away with. As regards colour, this is about ISO 64. With many colour

Ugandan children in a mountain village. Here I used a long focus lens to isolate the children from the jungle background. Nowadays I tend to use a wide-angle or standard lens and get very close. For some of us, it takes time before we lose our shyness about photographing people. (Olympus OM1, Zuiko 135 mm, from a Kodachrome II transparency.)

transparency films it is recommended to process them as soon as possible after exposure. Kodachrome is well known to be very tolerant of long delays in this respect. A small quantity of high-speed film may be useful in conditions of low light intensity such as early morning alpine starts and for photography on shadowy north faces in the northern hemisphere. It is also an idea to include some film for experimental purposes but generally it should be kept to a minimum unless you have room and money to spare.

Photographic spares should be kept to a realistic minimum. At least one spare set of batteries should be carried for each camera body and many more may be required if you intend to stay for several weeks in extremely cold conditions. In the latter case you could find that a change of batteries is required every few days unless you use lithium batteries or you are able to keep your equipment fairly warm. Don't forget that the same will apply to every other item which requires batteries such as flash and power winders.

A Skylight filter should be fitted to every lens you will use regularly and a spare one carried which can be fitted to other lenses using adaptor rings. At least one polarising filter is a good idea especially if it can be interchanged on

different lenses in the same way as for the spare Skylight filter. It may also be valuable and reassuring to carry a spare light meter, especially if your camera has an inbuilt meter. In the case of a suspected meter malfunction it can be used for checking, taking incident light readings or helping in setting the camera exposure manually.

Be sure to take a generous supply of sandwich-type plastic bags, rubber bands and sachets of silica gel. The former are useful for storing equipment and improvising weatherproof covers. The latter should be well desiccated in the oven and sealed securely in a plastic bag for later use should equipment get damp or need to be stored.

Before embarking on a long trip it is advisable to have equipment checked by the manufacturers or a recommended agent if there are any doubts as to its serviceability. Make sure that you allow sufficient time for this procedure to run its course. Some manufacturers are better than others but it can take as long as several weeks before equipment is returned.

Most cameras and lenses need readjustments and servicing from time to time to give reliable performance and it's no good finding out that all is not well after you have left home shores. The sorts of items which need to be checked are exposure metering, shutter speeds, focusing and aperture controls and signs of general wear and tear. It is often a good idea, if possible, to get to know the people who maintain your camera. It is in your interest to explain clearly to them what you intend doing and for how long you will be away. There are some manufacturers who are very concerned about giving good customer service and are interested to know how their equipment is to be used, particularly if the use is novel, imaginative or daring. It will also enable the servicing personnel to give possibly a more appropriate camera check-up as well as allowing them the opportunity to offer useful advice.

CARRYING PHOTOGRAPHIC EQUIPMENT

The mountain environment can be physically demanding. You may have to personally carry every item of photographic equipment you have brought. It is advisable to make prior experiments in carrying your proposed armoury of equipment. If you have made mistakes of judgement regarding the choice and amount it is better to find out sooner than later when you could make your own and your companions' lives a misery. A checklist of suggested equipment for long trips and expeditions is included in the Appendices.

PHOTOGRAPHIC INSURANCE

The most suitable form of insurance for the mountain photographer is an 'All Risks' policy. It really is advisable to take out this form of insurance if you use photographic equipment regularly and actively in the mountains. You only need to drop a piece of valuable equipment a moderate distance for it to be damaged beyond repair.

Most policies are limited to give you cover for loss or damage within certain territorial limits. These will be stated in the policy. Should you travel overseas you may need to pay an additional premium to effect the extra cover. It is important to tell the insurers exactly where you will be travelling, including those countries to be visited in transit, because theft can occur at any point on the way to your destination. You should itemise every piece of equipment you intend to take and keep a record of all the serial numbers.

It is also advisable to state precisely what your activity will be while overseas.

Such honesty may further increase the additional premium you will have to pay. However, the value of such honesty is often not realised until one has experienced the disappointment or uncertainty involved in trying to make a claim after a serious loss.

A little experience of travel is enough to make you realise that sophisticated and cunning theft is practised even in the most undeveloped areas of the world! If you have not informed the insurers of all the risks associated with your travel and value of your equipment they may well take the opportunity to deny your claim.

Choosing an insurance company is much like choosing photographic equipment. Ask around before you make a choice. Try to choose a company recommended by someone whose judgement is reliable. Remember too that an insurance broker may not necessarily be impartial in his advice or recommendations.

It may also be useful to question your insurers about what would happen if you made a claim. With an indemnification 'All Risks' policy, in the event of a claim, the insurers will make a deduction allowing for the age and condition of the equipment when lost. It is important to make sure that you specify whether you require a 'new for old' policy or a simple indemnification against loss.

It is important to retain all receipts for equipment which is insured. These are the only proof of purchase that you have. Without them you may have difficulty in having a claim settled for those items for which you cannot present proof of purchase.

TRAVELLING WITH CAMERAS

Generally there is little problem in taking photographic equipment through the customs of your home country. If you intend carrying a considerable amount of equipment it is wise to contact Customs and Excise well before your departure just to check if you could possibly encounter any problems on re-entry. If Customs suspect that you may have purchased some items whilst you were abroad you may need to carry proof of where the purchases were made.

Some countries – in Africa, Asia, Middle East and the Communist bloc – are sensitive about photography. If you have any doubts contact the embassy or consulate of the country and ask for advice and whether there are any restrictions on camera equipment which can be brought in. The sensitivity about certain photographic subjects, like railways, airfields and poor people, is usually restricted to the lowlands, and in most cases few problems are encountered in mountain areas unless you are close to certain border regions. The border between Uganda and Zaire runs through the centre of Mt Stanley in the Ruwenzori Mountains. Some mountaineers have encountered bizarre but frightening situations when they have been caught by officials in mountain refuges on the wrong side of the border.

In some regions of the Middle East and South America the mountain people can be very hostile to cameras. In the latter one can find one's self being pursued by a hoard of irate, stone-throwing women for daring to point a camera in their direction.

When travelling by air I recommend that you carry as much of your photographic gear as possible as cabin baggage. You only have to watch luggage being loaded and unloaded from aircraft holds to realise how rough the handling can be.

Most airlines subject cabin baggage to X-ray scan. Contrary to the signs on

many of these machines, X-rays do harm photographic film. Repeated exposure of film to X-rays is most likely to do damage and this applies equally to exposed and unexposed material.

Many airlines will undertake to inspect cabin baggage by hand but sometimes a little friendly persuasion is required. The regulations of those companies belonging to IATA (the International Air Transport Association) require that they provide this service if it is requested.

It pays to arrive at the airport in good time so that you can choose a moment to approach airport staff when they are under least pressure. Alternatively one can telephone the airport in advance to advise them of your requirements.

Lead foil bags can be bought to contain film but they are not always reliable protection against X-rays because the operator can increase the scanning intensity until the contents of the 'opaque' bag are revealed. Although it may seem preferable to pack film with luggage bound for the hold, I still prefer to carry it on my person and have rarely encountered difficulties with airport staff. Current information suggests that many airports now subject hold luggage to much higher X-ray doses than cabin baggage. However, in countries where drug smuggling is rife you may be unlucky enough to encounter an official who demands that film containers be opened, hence ruining the film. If you think that this is likely to happen then it would be advisable to pack your film separate from hand luggage.

The limit on cabin baggage is usually one piece not more than 4 kg (10 lb) in weight. On many trans-Atlantic flights you can carry cabin baggage and two other pieces of luggage with no weight restriction. This may not necessarily apply to connecting flights which sometimes have a limit of 20 kg (44 lb). To avoid being caught far from home with an excess weight charge it pays to check all weight limits well beforehand. These are usually stated on your ticket or can be obtained from the airline.

AVOIDING THEFT

Theft can be a very real hazard for the photographer in any country where there are large numbers of tourists. Try not to advertise the fact that you have a cache of expensive equipment. Equipment cases which are obviously for cameras are a 'give away' to the would-be thief. Similarly, try not to walk around festooned with cameras and lenses. Keep equipment which is not being used out of sight in a rucksack or bag.

Avoid wherever possible leaving equipment unattended. If this is absolutely impossible to do a good length of strong chain and a padlock is useful to dissuade the casual thief. It at least gives some psychological comfort if you have to leave gear in a relatively secure hotel room. Better still, leave the minimum of gear with the hotel manager if he seems trustworthy.

Airports, bus and railway stations are very high risk areas. Sneak thieves some-times work as a team, one distracts your attention while another grabs a bag from under your nose and is off before you know what has happened. To make it more difficult for this to happen tie all bags and straps together or loop an arm or leg through them, especially if you are sitting down or trying to cat-nap.

In some areas thieves carry razors to slash camera straps and bags. I have met enterprising photographers who have passed wire through straps and reinforced the lining of camera bags with wire mesh to thwart such attempts.

You should make a note of all the serial numbers of your cameras and lenses and keep it on your person at all times. These details will be essential if you need

to report a theft and for insurance purposes; they are also vital for the proper identification of your equipment should any be recovered after a theft.

MOUNTAIN HAZARDS

COLD

Wherever possible try to prevent cameras and lenses from being exposed to freezing cold for long periods. Although the cold itself does not cause damage any moisture or condensation which turns to ice could cause moving parts to seize. When water freezes it expands and this could cause damage if moisture is trapped between the glass elements of a lens or viewfinder. Once the glass elements of a compound lens have begun to become unstuck this may later offer a site for the growth of fungus, causing further damage.

Lubricants such as oil and grease used in lenses and cameras become increasingly viscous with cold and may also cause parts to seize or get so stiff as to be nearly inoperable. For this reason some camera manufacturers used to recommend that their equipment be 'winterised' should it be likely to be used in extremely cold conditions. This does not apply so rigidly to modern photographic equipment which uses silicon based lubricants, but it is still worth contacting the manufacturers for information and advice if you are in any doubt. 'Winterisation' requires the removal of all lubricants and sometimes replacement with a 'dry' lubricant or a more suitable low viscosity oil. This procedure is generally expensive and has to be reversed once the equipment is being used in more moderate temperatures.

Unless conditions are very extreme much can be done to avoid equipment reaching freezing temperatures. Cameras can often be kept inside clothing and warmed by body heat. Remember that the warmth of the body is also accompanied by high humidity. Every effort must be made to minimise the length of time the equipment is exposed to the air so that any moisture or condensation does not freeze.

In very extreme cold film can become especially brittle. This means that particular care must be taken to be gentle when loading, rewinding or advancing film. It may even be worth experimenting with pocket warmers or similar devices which can be attached to the back of the camera to prevent film from becoming too cold. Cold air is also often very dry. For this reason one must be very careful not to rewind too quickly otherwise static electricity may be generated, causing fogging of the film. In extreme cold it may be argued that a camera with a black finish may keep slightly warmer than one with a chrome finish provided there is some radiant heat about.

Many modern cameras rely on batteries to operate exposure meters and even shutters. Most batteries become less effective as they become colder. For this reason they often need to be regularly replaced when used in extreme cold. It is wise to carry a large number of spare batteries kept warm next to the skin to facilitate easy replacement in the field. The 'used' batteries can be retained and used quite successfully once the photographer has returned to more moderate temperatures. Recently lithium batteries have appeared on the market which are suitable for use in cameras. Their power output is much less affected by low temperatures and they are not as inclined to go flat during storage, making them particularly useful in the mountains.

Lenses and cameras are still largely made of metals, though synthetics such as poly-carbons are becoming more commonly used. Moist skin can rapidly freeze on to metal at sub-zero temperatures. A rubber eye-cap on the viewfinder

can prevent the cheek or eye-lids from coming into contact with the metal of the camera as well as excluding extraneous light which could adversely affect some TTL exposure meters. Furthermore, bare hands and fingers can quickly lose mobility and sensation when exposed to cold and this can be accelerated by handling the metal and controls of the camera. This is one reason for using or making a special case which surrounds, protects and insulates the camera.

One can also experiment with fingerless mitts or gloves which have a flap on the palm which allows the fingers and thumbs to be freed. In extreme cold it is often a good idea to wear two pairs of gloves. The innermost pair should be thin; silk, cotton or synthetic fabrics are ideal; so that when the outer, thicker pair of gloves or mitts are removed the camera can be operated easily. To prevent the risk of losing mittens an elastic loop can be sewn onto the cuff of the mitten and placed snuggly over the wrist.

HEAT

One should always use common sense and avoid leaving equipment exposed to the heat of the sun for any appreciable length of time. Extreme heat can soften the cement which holds the elements of a compound lens together. Heat rays can also be focused on to the shutter by a lens left pointing at the sun without the lens cap, causing damage. One should always bear in mind the problems and precautions already mentioned in Chapter 3.

Cameras and lenses can become alarmingly hot in a relatively short time especially if they have a black finish. Certainly a camera with a chrome finish absorbs far less radiant heat. However, equipment can be easily protected from the sun simply by covering it with clothing or a handkerchief. Since most camera and lens cases are matt brown or black, in some instances it might be worth giving serious consideration to using alternatives or painting or covering the cases with a more reflective material.

One problem which can arise with telephoto and long focus lenses when they become too hot is an inability to focus sharply at long distances. This is due to the expansion of the metal of the lens barrel causing the glass elements to move fractionally further away from the film plane. Some modern lenses allow the photographer to compensate for this by allowing extra rotation of the focusing ring past the usual 'infinity' setting or by careful lens design to minimise this problem.

In most cases the key to protecting equipment from the high diurnal and low nocturnal temperature variations of mountain regions is to be aware of the potential problems and to be able to take the appropriate measures when they are required.

DUST

It is quite surprising the variety of material which can find its way inside lenses and cameras. Dust, grit and sand are the most notable but one Hasselblad was even found to contain the remains of locust!

Foreign material, especially mineral particles, can increase the wear and tear on mechanical and moving parts. The best way to prevent the entry of dust and grit is to keep equipment covered whenever it is not being used. Above the snowline this is not quite such a problem, but below while tramping across moraines or anywhere that the ground is not covered by ice or snow one must be careful. In these circumstances it may also be useful to use a camera case which need not be removed while operating the camera.

RAIN, SNOW AND MOISTURE

The amount of rain or snow which comes into contact with equipment can be minimised by keeping it covered or in cases. This is possible even when equipment is in use. There are rain covers, like those made by EWA, available for cameras. One can also easily improvise with anoraks, umbrellas, plastic bags and home-made cases. Superficial moisture should be removed immediately from camera and lenses with a paper tissue and a supply should be kept handy in a plastic bag for this purpose.

If you suspect that moisture has got inside your equipment make sure it is packed inside an airtight bag or container with a desiccant for at least 24 hours as soon as possible. Details on the use and reconstitution of silica gel are contained in the Appendices.

BIOLOGICAL HAZARDS

The prevention of the growth of fungus, often in the form of mildew, is the main problem for the photographer. However, he is unlikely to encounter much of a problem while temperatures remain low as this inhibits fungal growth. The problem usually arises after he returns to a warmer climate. Any moisture inside the camera or lens can provide an ideal niche for the growth of fungal spores which may have been collected and lain dormant for a long period of time.

Obviously the best prevention is to ensure that equipment is not allowed to get wet or accumulate moisture in the first place. Packing in desiccant may inhibit or prevent further growth of fungus but unfortunately fungal spores are highly resistant to desiccation and growth may resume once the equipment is returned to normal humidities. If a fungal infestation appears to have become firmly established it may be best to store the equipment in silica gel until professional assistance and advice can be obtained.

Mites are actually quite common inhabitants of cameras and it can come as quite a shock to see one for the first time marching in high magnification across the focusing screen. Generally mites which invade equipment will only remain if food and moisture is available. Provided equipment is kept clean and dry inside and out, any mite infestation will usually cease. Mites will not breed unless the conditions are exactly right but make every effort to remove any which are seen. By keeping equipment sealed away with a desiccant this will prevent entry of mites and generally kill any that are present.

ADAPTING AND MAKING SPECIALIST EQUIPMENT

The need for specially designed equipment becomes more apparent in this field of photography as one gains more experience. The three most basic requirements of the active photographer are that the gear should be well protected, conveniently portable and easily accessible. In the mountains or wilderness these three requirements are even more essential due to the nature of the environment and the physical demands on the photographer.

With a little ingenuity and imagination a number of useful accessories can be made or adapted. Most of the material which you might require, such as waterproofed fabric, synthetic webbing and polyurethane foam, is readily obtainable in sporting and camping shops.

CAMERA CASES AND STRAPS

The problem with most camera cases and straps is that they are designed for the person who carries the camera over his shoulder for short periods of time in sunny weather or with shelter near at hand.

The mountain photographer soon discovers that the case is not weatherproof and the strap is too narrow to support the weight of the camera comfortably over a whole day. Furthermore in bad weather the case must be partially removed before taking a photograph, so allowing the camera to get wet.

A few manufacturers produce clear plastic rain covers for cameras but this may not be enough. Thin sheet polyurethane foam can be used to provide extra protection against knocks and scratches. It is ideal for a variety of applications because it is non-absorbent and an excellent thermal insulator. It is also easily worked and can be glued using impact adhesives. If a tough, waterproof fabric is glued on the outside of the foam gradually a tough, versatile, weatherproof case for cameras and lenses can be constructed. Depending on the design of your camera it may be possible to make a case which allows you to reach the vital controls and take a photograph without removing it. This can be a distinct advantage when in continual rain or snow.

A broader camera strap can easily be bought or made. A simple buckle will allow the strap to be conveniently adjusted in length.

The weakness with some cameras is the point of attachment of the camera body to the strap. This area also creates problems when designing a weatherproof case as it remains a potential point of access for rain and water. If your camera is likely to receive some very rough treatment it may be worth considering mounting the camera on an outer bracket attached to the camera at the tripod socket. The bracket can then be attached to the camera straps while its base and sides provide physical protection. One can even mount a small hot shoe for electronic flash on this bracket. This can be coupled by a short lead to the camera's flash synchronisation socket so that the new case does not have to be removed when one wishes to use flash.

LENSES AND ACCESSORIES

One of the problems with lens caps is that they tend to fall off. On a trip away from home the loss of a lens cap can have serious consequences. To prevent this from happening lens caps can easily be attached by a short cord to the lens barrel. Ready-made attachments can be bought or you easily make your own by using light nylon cord.

Lens hoods and cases for stacked filters can be made from black polyurethane sheet foam. The former can be particularly useful because many of the proprietary lens hoods are easily dented or are far too shallow to do their job adequately in the glare of the snow or mountain sun. Furthermore a foam lens hood can simply be pushed into a pocket when not in use.

Another useful idea is to fit a cap on to the hood rather than the lens. This avoids the inconvenience of having to remove the lens hood every time you wish to cap the lens.

EQUIPMENT BAGS, BELTS AND POUCHES

Some outdoor sports manufacturers are producing equipment to meet this demand. However, you may also find that some items of general equipment can be easily adapted to carry photographic gear with the addition of a little padding and partitions. At this stage it is really necessary to be able to use a

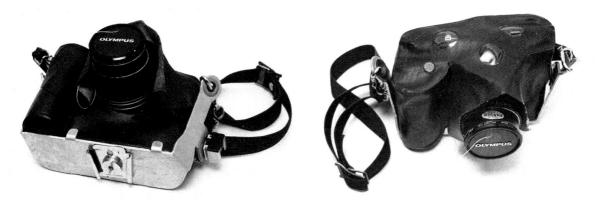

Home-made all-weather camera case and bracket. This is an extra large case which allows me to use an autowinder fitted to the camera. Although I regard myself as very careful about my equipment I do break cameras and the metal bracket affords an extra measure of protection. I can also attach a flash to the accessory hot shoe on the side without having to remove the top of the case.

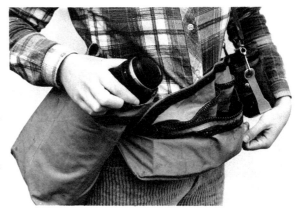

Equipment belt and pouches. This belt contains the following lenses, 300 mm, 180 mm, 100 mm, 50 mm and 24 mm. It can also hold film, lens hoods and filters. This is what I might use on an assignment where I need to be very mobile and don't want to carry a case. On a climb or walk one would probably reduce the weight and bulk considerably. It was made on a domestic sewing machine and the most expensive item was the heavy duty zip.

sewing machine especially if you intend to design and make your own bags.

A fairly simple equipment belt can be made from a sheet of fabric turned into a tube with the addition of a strong zip, nylon webbing and the sewing in of a few partitioning strips. The zip should be covered with a flap to prevent the entry of rain. A simple modification to a heavy duty zip with a double slider can be particularly useful. By removing the plastic or metal stops at the ends of the zip both of the sliders can be removed. The sliders can now be reversed and replaced on the zip. The zip now opens from the centre instead of the ends and will provide a narrow aperture allowing access to the selected pockets of the belt. This prevents any items from falling out of the belt when opened and rain and snow entering when you need to withdraw one particular item. The value of this modification may only become apparent when your photography takes you to more airy and precarious locations.

CAMERA SUPPORTS AND CLAMPS

There is a wide variety of camera supports available to which your camera can

be attached. Some of these are highly versatile and can be secured in a variety of ways. However, it may be difficult to obtain a clamp which can be attached to an ice axe. If you cannot find a clamp which will fit on to the head of your ice axe it should not be difficult to design one which could be made by a small engineering works.

CLOTHING

Most outdoor clothing has large pockets which are ideal for holding the smaller items of equipment. It is sometimes an idea, however, to consider redesigning, enlarging or adding pockets. For example, if a particular pocket is found not to be sufficiently waterproof it may need to be replaced or a new waterproof lining added.

Inside pockets can be a useful addition as this is where equipment is most protected from knocks and weather.

Sewing a fabric which has a waterproof coating can be fraught with problems. The major problem is that each new or old needle hole which is exposed will need to be sealed to prevent the garment from leaking water in a downpour.

WEATHER AND SEASONS

The effect of the weather and season on the mountain environment is one of the most attractive features of this type of photography. Mountains often have their own weather pattern which can at any time be quite different from that of the lowlands as well as being far less predictable.

Photographs where the sky is always blue with the odd fluffy white cloud can get pretty boring as well as the fact that they reflect none of the drama and magic of the mountain environment. Those who have not spent the night bivouacking on a windy ridge in the hope of getting that special shot in the dawn as the clouds clear momentarily have denied themselves a unique experience and a marvellous photographic opportunity. Obviously in such situations you need to be an experienced and well-equipped outdoorsman. Someone who goes out naively into bad weather could be asking for trouble.

It is important to state that no one should ever think that good weather is needed to get good mountain photographs. Nothing could be further from the truth. If you want atmospheric photographs which are out of the ordinary then try getting into the hills when the clouds are racing and the wind is whistling.

When a particular mood or atmospheric condition is required it may be useful to know something about meteorology and to try to develop your knowledge of this science. Even a basic knowledge of weather conditions and their controlling factors can be useful. Particular conditions of mist or cloud formations are produced by a certain combination of weather factors which are likely to be repeated in the future.

Generally speaking in the UK the most dramatic weather conditions occur as a front moves through an area. This can often be associated with particularly dramatic lighting at dawn and dusk. After a cold front has passed the skies are often startlingly clear.

It always pays to find out a little about the climate of a region and use this in conjunction with some forethought about the photographs one wishes to get before venturing to far-off places.

If you intend to travel to a region you have not previously visited, particularly

overseas, try to get in touch with someone, preferably a photographer, who has been there before. Be wary of advice or information given on this subject from travel and holiday companies. Very often their advice may only apply to the lowlands and they may be inclined to tell you what they think you would like to hear.

Always remember that the weather in the mountains, especially at high altitudes, can be the reverse of that in the lowlands or by the coast. For instance, on the west coast of South America, winter leaves the coastal areas heavily overcast while at the same time the mountains experience dry weather and clear skies for most of the time.

The subject of mountain weather has only been dealt with superficially here because it is far too complicated to be included in the scope of this book. For further research some useful titles are recommended in the Appendices.

CHAPTER 6 HOW TO CLIMB AND TAKE PHOTOGRAPHS

INTRODUCTION

Once, when faced by a mountaineer whose expensive camera lay in his hands, crumpled and smashed after being dropped 200 ft, I was told, 'Photography and climbing just don't mix.'

In many ways he was right but there are also a large number of climbers and mountaineers who have made the combination work.

THE RELATIONSHIP BETWEEN THE PHOTOGRAPHER AND THE CLIMBING TEAM

The situation for the modern mountaineering photographer is quite different from that of a decade or more ago. The age of large multi-camp expeditions has passed and has been replaced by the small, fast-moving team climbing in alpine style. This means that more and more the photographer has to be an intrinsic part of the climbing team and must be a very confident and competent climber. Invariably this also means that unless the rest of the team is particularly accommodating or understanding he must subordinate some of his photographic needs to those of his companions.

Top climbers and mountaineers are generally fanatically dedicated to their craft, and any one wishing to be more than a 'run-of-the-mill' climbing photographer must, without doubt, be completely dedicated.

The mountaineering photographer has the extremely difficult task of serving two very demanding 'masters'. He must meet the needs of his climbing companions because he is often a necessary part of the team. He then has got to be able to find the energy and motivation to handle a camera. It is very difficult to do both jobs well and often one has to constantly juggle two conflicting demands. Absolute dedication to the task is required by the photographer while at the same time the priority must always be the safety of his companions.

My experience of climbing in very difficult circumstances is that most people can't spare the effort and mental energy required to take photographs. I have even known climbers, having invested in expensive camera systems and film, who have not once used their equipment during a spectacular and photogenic ascent. To take photographs means that you must be prepared to carry the weight of the necessary equipment. At altitude the prospect of even a few extra pounds can be extremely daunting. Furthermore, the equipment has got to be kept accessible and this also causes inconvenience.

During a difficult ascent climbers are under extreme mental and physical stress. One only has to have watched some of the television documentaries on mountaineering to see that even highly experienced climbers who have known each other for years can 'fall out' to an extent where the drive and motivation of the team as a whole crumbles. Photography can easily complicate an already tense situation. One must decide when one's assistance is vital to the success of

the trip and how one's behaviour may be increasing the stress and mental load of one's companions.

The photographer has the difficult task of trying to see himself in the way the rest of the team does. It is highly likely that they do not understand why you are taking photographs in the first place. There have been many times when I have been told that I must be 'mad' to carry the extra weight of cameras and be prepared for the additional inconvenience this causes.

Certainly it will help your cause if you make sure that the members of the team have seen some of your photography before you go on an expedition. This applies especially if you are not well known to the rest of the team. You must expect that it may not radically improve their sympathy for your particular brand of 'insanity' but it may help to allay some suspicions about your motivation. A great many climbers are unromantic about their sport and dislike any hint of sensationalism or publicity. It's up to the photographer to show that he has his feet firmly on the ground.

In the case of the very large 'high-powered' expedition it is common that all photographs taken during an ascent become the property of the expedition as a whole to help pay off debts through publications and illustrated lectures. In these situations there is often considerable incentive for photographs to be taken and team members are keen to co-operate with an individual who is acting as the team's photographer. Where the circumstances are more modest the photographer can obtain more sympathy and co-operation if he offers to furnish his colleagues with duplicate photographs at the end of the trip.

One of the most important things that the photographer can do during an ascent to maintain the confidence of his colleagues is to show that his priority, first and foremost, is their safety. He can also help himself considerably by ensuring that he is sufficiently competent and familiar with his equipment to be able to take a photograph with the minimum of fuss and delay: If you think carefully about the sorts of shots you want and learn to anticipate events in advance you will learn to have the right equipment to hand at the right moment. This will prevent the need to make the dreaded request to repeat a move – something which is almost guaranteed to make you unpopular.

You should not underestimate the dulling of mental capacity which accompanies days spent at altitude in extreme cold. The camera has got to be second nature to you, almost an extension of your hands and mind, so that its use and manipulation become almost automatic. You can't afford to delay while trying to decide what lens you need or what exposure compensation is required. You should be able to change film and lenses one handed if necessary. It may all sound a bit extreme but you owe your companions this degree of competence to ensure their safety and minimise further stress.

However, despite one's commitment to the team there will be times when you have to 'step back' from your personal involvement to document certain incidents. This can be very difficult in practice. For instance, what do you do if someone falls or is injured? Do you take photographs? The answer depends a lot on the attitude of your companions to you and how involved they feel with the photographer's endeavours? Some individuals might become extremely hostile if you took photographs in such circumstances, others might be very disappointed if you refrain, especially if the incident ends happily.

There are many parallels between mountaineering and war photography. In each case there is often severe discomfort and personal danger and at the same time one is closely involved with others in the same situation. If you feel strongly enough to justify taking photographs in a sensitive situation this is often the best criterion for aiming the camera and pressing the button.

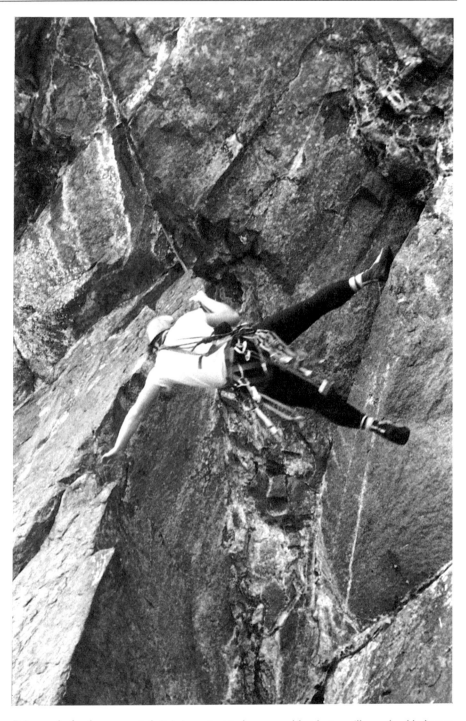

Being ready for the unexpected. It is important to be prepared but better still one should observe and learn to anticipate events. The climber had reached a difficult move and I suspected he would fall off. When he took a 'swing', held on the rope by the leader above, I was ready with the focus and exposure set. Because it was relatively dark a slow shutter speed was used but this was insufficient to freeze the movement of the climber.
(Olympus OM2, Zuiko 100 mm, FP4)

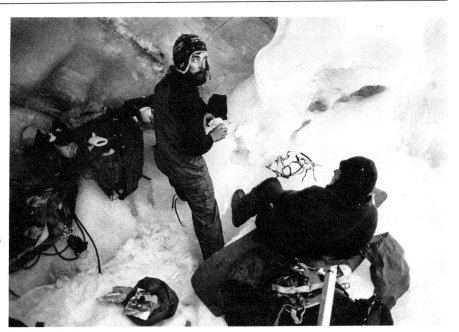

Crevasse bivouac. Strain and fatigue show on the face of this climber. When climbing I think it is important to show the mundane and domestic scenes as well as the spectacular.
(Olympus OM2, Zuiko 24 mm, FP4.)

The good climbing photographer has to have a fierce driving force gnawing away inside him if he is to do a good job. The 'pure' climber is motivated by the challenge of the ascent. The photographer has got to be motivated by the desire to record the ascent. This motivation must be exceptionally strong if it is to enable him to maintain a sufficient degree of single-mindedness despite fear, fatigue and frustration.

HOW TO TAKE PHOTOGRAPHS WHILE CLIMBING

Taking photographs when there are two of you climbing can be difficult. You simply can't hold a camera if you are supposed to be holding the rope.

Very often it may be better to take photographs when the other climber is near to your belay point because he may soon disappear out of sight. Sometimes it may not be possible to ask your companion if it is safe for you to take a picture. Here you must use your own judgement and experience. It is unwise to let go of the rope unless your companion has reached a safe spot. Some belay devices like Sticht Plates allow a slightly greater margin of safety in this situation.

Because communication is so difficult in the mountains it is often better to develop a climbing partnership so that each gets to know the confidence, skills and requirements of the other. It is most important that you keep all your equipment near at hand so that the taking of photographs occupies the minimum amount of time. This calls for judgement and anticipation, both of which improve with experience.

The ability to anticipate will allow you to select the right equipment and even prefocus and set the exposure in an entirely safe situation. When the right moment arrives you can take a photograph in a fraction of a second.

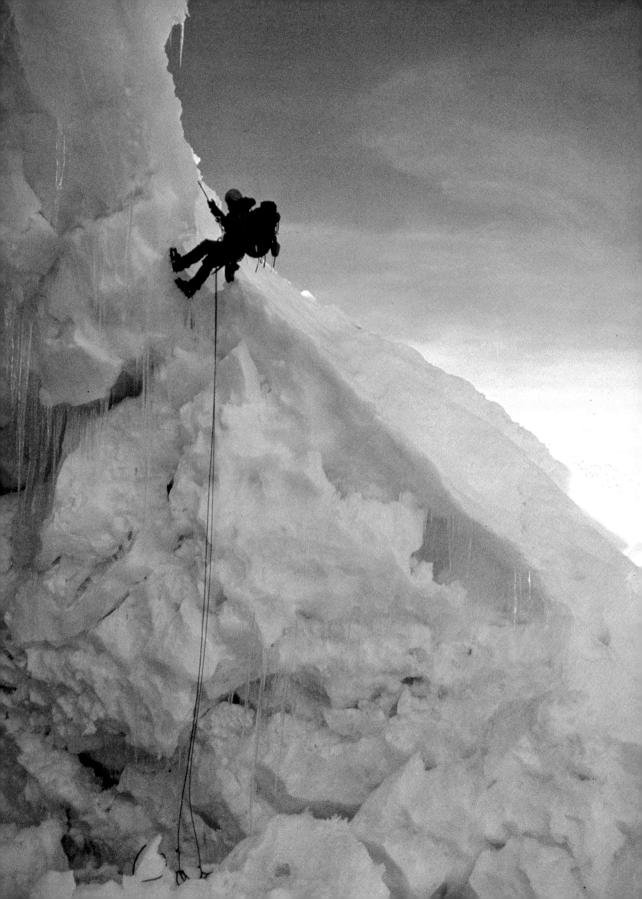

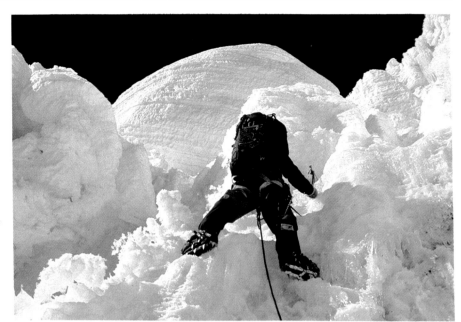

Climbing steep ice high on the north-east face of Nevada Alpamayo. I overexposed about one stop on a reflected light reading from the snow. Note how dark the sky is; the only filter was a Skylight 1B. (Olympus OM2, short range zoom, Kodachrome 64.)

Organise your equipment so that exposed and unexposed film is always kept clearly separate but near at hand. This is where a small equipment belt or bag is indispensable. Make sure that you are sufficiently familiar and practised with your camera that film and lens changes can be done quickly and smoothly. Concentrate on developing your eye for a photograph so that you can be ready with the right lens at the right moment. This will also put you in a better position to catch the unexpected incident which may often make an unusual, even startling, photograph.

Many of the photographer's problems depend on the difficulty of the route being climbed. It will, to a large extent, determine what can be carried and how often it can be conveniently or safely used. On an extremely severe route it may be impracticable or unwise for the photographer to be the lead climber simply because a camera cannot be carried if the climbing is technically or physically confined. In these sorts of situations a large front pocket in an anorak or a camera with a very short strap is advisable. In the latter case the camera can be swung out of the way, under the armpit or behind the back. The short camera strap can also be used to steady the camera in poor light, the strap being passed under one or both arms and the length adjusted so that it is taut when the viewfinder is brought to eye level. By using opposing forces like this considerable steadiness can be achieved.

If you are climbing with a group you are in a much better situation than if there are just two of you. You may be able to photograph the activities of the other climbers while causing less concern to your colleague.

Being part of a rope of three can be a positive advantage because the photographer doesn't necessarily have to belay and by varying his position on the rope can get pictures of the other climbers from above and below. However, if you are always directly above or below the other climbers you may often find the resulting photographs are disappointing views of boots or backsides,

Abseiling down an ice cliff in the Peruvian Andes. (Olympus OM2, Zuiko 24 mm, Kodachrome 25.)

The importance of eye-to-eye contact. A lot can be read into a shot when one can see the face and eyes of the subject. The slight look of apprehension on the face of the climber is reinforced by the limited depth-of-field and the steep camera angle suggesting exposed position. (Olympus OM1, Zuiko 50 mm, FP4.)

or legs and arms! One can be surprised at the success of photographs taken from above or below at an angle. Often this allows the inclusion of distant and middle distance features which give a much greater impression of scale.

It is worthwhile remembering the importance of showing faces clearly in the photograph. Even if the danger or exposure of situation cannot be made truly apparent by altering the camera angle alone, facial expression can indicate a lot of information not contained in the photograph.

TAKING PHOTOGRAPHS AT ALTITUDE

Altitude creates three problems for the photographer: increased cold, considerable change in the quality of the ambient light and decreased mental and physical capacity.

At low altitudes the sky is blue due to the scattering or refraction of sunlight by the atmosphere, water vapour and dust particles. While the sun is the main source of light varying amounts of 'fill-in' light are coming from other areas of the sky and clouds, reducing contrast between light and shade and giving an overall bluishness and haziness to the surroundings. This is the environment we are most used to and in which our film – colour film in particular – is designed to give the best results.

At high altitudes the sky becomes quite dark, almost black straight above,

Humour at altitude. This wasn't a pose. In a light-hearted moment after a hard climb a colleague broke off an icicle and put it, Marx brothers-style, in his mouth. I swung the camera and took a quick shot.
(Olympus OM2, short range zoom, from an Ektrachrome 200 transparency.)

because there is far less atmosphere, dust and water vapour to scatter it. There is also considerably more ultra-violet at altitude which is normally filtered out by the atmosphere at lower altitudes. This makes the control of contrast and correct exposure particularly difficult.

Every lens should be equipped with a Skylight or UV filter to absorb this excess ultra-violet which may otherwise cause a bluish tint to photographs. A polarising filter can help to control reflections but it will have little effect on the already dark sky.

Although the reflection of light from ice and snow may help to 'fill-in' shadows, a particular problem, especially when taking photographs of people at high altitude, is increased contrast. Nothing can be done about it, except by using an electronic flash for a fill-in light, and the increased contrast gives particular drama to some photographs. The key to overcoming such problems is to expose the film correctly and to be aware of some of the pitfalls produced by high contrast.

With glaring light from the sun and reflections from ice and snow, exposure meters can easily tempt one to under-expose, producing grey snow and ice, black faces and dull clothing. Wherever possible take a light reading from a standard surface. Skin and clothing can serve this purpose particularly if you have compared them against the light reflected from an 18 per cent grey card. It might be possible to carry a grey card but this may not be practicable, in which case the former is a good alternative. In general, because reflection from ice and snow is so strong, it is best to err on the side of under-exposure when taking reflected light readings from snow which will give good textural qualities to such surfaces although figures may tend to be a little dark. One may also take an incident light reading using an appropriate meter. Once again, unless you are surrounded by surfaces of low reflectivity such as rock or taking portraits it pays to under-expose by about a full stop due to the amount of reflected light.

Nevada Huandoy Oeste (6356 m) from the glacier below Nevada Huascaran. No polarising filter was used but the shot was under-exposed to retain plenty of detail and texture in the ice and snow. (Olympus OM2, short range zoom, Kodachrome 25.)

Even slight over-exposure by half to one stop will give a wishy-washy effect. One must remember that film exposure is a compromise and in conditions of fierce light film – in particular colour film – will only allow some of your surroundings to be acceptably rendered because of its limited exposure latitude. When at a loss it may pay to take a number of light readings by the different methods and arrive at an average. I have usually found that good results are obtained if I take a general reflected light reading which includes a lot of snow and over-exposure by half to a full stop.

If you wish to take portraits of people with dark complexions at altitude remember that their skin will appear quite black on a photograph unless you over-expose a little or use flash.

Generally it is difficult to take a photograph while wearing snow goggles which project a long way from the face. Be wary of leaving goggles off for very long or forgetting to replace them immediately you have taken a photograph otherwise there could be a risk of snow blindness.

So far we have dealt with only the physical and not the physiological aspects of photography at high altitude. Camera-shake can be a problem when panting

or gasping for breath even after mild exertion. This is also true when trying to use a cine camera to get steady shots while at the same time your chest is heaving for breath. If you have a light monopod it can be used as a pistol grip. You can even place the end of the monopod into a loose strap around the neck to further steady a movie camera. However, you will often find that a little self control can steady your breathing for the few seconds needed to gently squeeze the shutter button, while the camera is pressed firmly against the face and elbows are kept in tight against the chest.

SELF-PHOTOGRAPHY FOR THE SOLO MOUNTAINEER

This may seem like an esoteric subject but it may well have relevance to other areas of photography in the mountains. There could be a number of situations where a mountaineer needs some device which is more sophisticated than the camera's self-timing mechanism to take delayed action remote photographs. Brief details of some of the major types, their advantages and disadvantages are listed below.

MECHANICAL DEVICES

These are usually clockwork mechanisms which screw into the shutter release button. Varying delays can normally be set. The range of delays available is fairly limited and their greatest application is when the camera lacks an integral self-timer.

ULTRA-SONIC TRIGGER DEVICES

These systems rely on batteries. A compact transmitter, often about the size of a cigarette pack, generates ultra-sonic sound waves. These are picked up by a receiver, provided it is within range, which mechanically triggers the camera. The receiver is screwed directly into the shutter release button but some can connect electrically, via a cord, to an autowinder. The effective range is generally less than 50 m (164 ft). Ultra-sonic signals can be 'bounced' to a limited extent if the receiver is not within the line of sight but the range stays about the same. The transmiter has to be aimed at the receiver to get it to work at near maximum range.

INFRA-RED TRIGGER DEVICES

Nikon make such a device and a number of other manufacturers market their own designs. Both receiver and transmitter are again about the size of a cigarette pack. The receiver has a reception arc of about 60° and the transmission arc is about 30° to 40°. The maximum range is greater than the ultra-sonic trigger but varies with the make and specifications. As with the ultra-sonic trigger device, the transmitter must be aimed directly at the receiver. The receiver generally has a lead which will connect with a camera's autowinder or motordrive unit.

RADIO-CONTROLLED TRIGGER DEVICES

So far all these devices have been listed in rough order of expense. In general radio control is the most expensive but it also is the most versatile, has the greatest range and in many cases is slightly bulkier. The latter depends very

much on the make and is also determined by the size of batteries required. The receiver plugs into an autowinder or motordrive attached to the camera. The range can be more than a kilometre. Obviously the more powerful the unit the bigger it will be. A model built for use with model boats and planes can serve the purpose but in this case the transmitter is often fairly large.

Remote triggering devices which can only connect to the camera's shutter release button are virtually useless because they will only allow one exposure. Therefore, in most cases an autowinder at least is necessary if repeated exposures are required. Their use in cold conditions has already been discussed. This increases the need to rely on batteries and involves increased expense and weight, but for someone with a specialist requirement it may be worth the extra cost and inconvenience.

CHAPTER 7　　　HOW TO LOOK AFTER YOUR PHOTOGRAPHS

For most people photography is a way of encapsulating their memories and preserving them for the future. If the photographs are stored without order and are inaccessible they rapidly become neglected. Once neglected, they are more easily damaged, sometimes beyond repair, and they can no longer fulfil the purpose for which they were originally taken.

Such risks can easily be avoided by maintaining good after care of your photographs and by intelligent storage you can derive far more pleasure from them.

EDITING, CAPTIONING AND CATALOGUING PHOTOGRAPHS

It is absolutely essential that a photographic collection is continually pruned of second rate material. The earlier that one begins this discipline the better because even the occasional photographer can rapidly amass a large, unwieldy collection. This lesson is often only learned when one comes to use photographs for a slide show, to illustrate an article or simply to show friends. One can spend hours, quite unnecessarily, sorting out a few good photographs from a vast stock which could have been a fraction of the size.

The process of editing not only makes photographs more accessible but also helps the photographer to develop a critical eye. This is vital in the creative and technical growth of the photographer. As one gains experience one learns to avoid repeating previous mistakes.

Transparencies are best analysed and edited during projection. Unless you have a very experienced eye it is difficult to do this using a light box or an illuminated magnifier. Editing prints is much more straightforward and becomes progressively easier as the print size increases. If you are working from contact prints a small magnifier or lupe is required. The most convenient type to use has its own stand or support.

The criteria for judging whether a photograph is second rate are not hard or fast. You must decide on those which fit your ambitions and requirements. As a general guideline discard photographs which have obvious technical errors such as poor exposure or focus, those which are badly composed and lack impact and those which show any signs of physical damage.

Editing should be an on-going process. Often, at the first showing, some photographs which might have been discarded are retained for sentimental reasons. The passing of time enables one to be more impartial when selecting photographs.

It is occasionally useful to keep rejects and to file them separately. They can act as a source of reference when attempting to develop a technique or effect which has previously been unsuccessful.

Prompt captioning of photographs is vital in maintaining an informative and useful collection. Dates, names of people and places and directions can rapidly

slip from one's memory. Details of camera, lens, film, shutter speed and aperture also provide constructive information for future reference. Transparencies are often marked with the exposure number but it may be useful to include this information on the back of a print too. This is easily done by using an adhesive label.

It is advisable to either type or neatly write the information on an appropriate size of adhesive label. This can be attached to the broader edge of a slide mount or to the back of a print. Alternatively you can simply write a catalogue number on each photograph and record a caption on a separate sheet. The obvious advantage of this system is that a much more detailed caption can be supplied because you are not limited by space. However, problems do arise if you intend to submit photographs for publication or competition. It may then be necessary to re-write new caption lists for each individual selection.

At this stage I also find it useful to place a red spot on the bottom left-hand corner of the mount. This makes for easier and more accurate loading of slide magazines because the transparencies merely have to be inserted with the spot at the top right hand corner facing away from the screen to ensure correct projection.

Another very good idea if you intend to have photographs published is to obtain a small rubber stamp which includes your name and address. Publishers sometimes see thousands of photographs each day and they are less likely to go astray if stamped accordingly. This procedure will also make your work seem more professional.

FILING AND STORING PHOTOGRAPHS

The real boon of an intelligent filing system only becomes apparent if you have begun to use catalogue numbers on your photographic collection. It will enable you to retrieve particular photographs more easily as well as enabling you to keep track of those which may have been sent away.

The degree of sophistication and the method of storage of your photographs will depend on what you can afford and the emphasis which you place on the ease of their retrieval. Transparencies are most commonly filed in slide boxes and cases, linear and rotary magazines and slide pages. The latter can either be kept in a ring binder or suspended in a filing cabinet.

Prints are most commonly filed in albums or wallets which can be stored in filing cabinets. The items most often neglected are the negatives. Some albums provide for their storage. One can also purchase negative pages of special paper or acetate sheet for this purpose. These can be stored in a ring binder accompanied by their contact sheet or filed in a cabinet.

My personal preference is to store transparencies in plastic wallets suspended in a filing cabinet. A large number of shots can be stored in a relatively small space and one can see 24 slides at a glance which greatly speeds up the process of selection and replacement. I also prefer to store negatives and contact sheets in a cabinet with moderate sized prints in accompanying wallets.

Slide magazines, although convenient for projection, are bulky and rather costly considering the relatively small number of transparencies which some of them hold. Transfer magazines are also available which provide a simpler system for loading slides into linear or rotary projector magazines. Some of these systems can be stacked, which makes for more convenient storage.

Slide cases too may be expensive. It depends largely on their size and type of construction; for example, there are some which can be stacked and built into

storage systems. However, there are wide discrepancies in prices between all these various systems and it pays to shop around.

When storing any photographs bear in mind the points made in the earlier section on caring for exposed and unexposed material. Processed film is still very susceptible to damage by humidity, heat, light, chemicals and fumes, mildew and small organisms. Most processed photographic material deteriorates very gradually with time. This process can be kept to a minimum by making sure that all photographs are enclosed and in the dark, away from damp, at moderate room temperatures (15.6°C to 21.1°C; 60°F to 70°F), where there is reasonable ventilation.

Covering and enclosing your photographs will prevent the accumulation of dust and exclude fumes and contact with chemicals as well as excluding light. Most paper and cardboard and many plastics contain acids and plasticizers which are used in their manufacture. These chemicals can be very harmful to photographs. Only use storage materials and containers made specifically for use with photographic materials or which you know are free of these harmful substances.

DISPLAYING PRINTS AND TRANSPARENCIES

Any photographer will at some time wish to display prints or project his transparencies. This is a fascinating and complex subject which I will not attempt to cover in any detail here. (Recommended further reading can be found in the Appendices). However, some general guidelines can be given which may help to direct further reading.

Remember when choosing somewhere to display prints that colour photographs are inclined to fade if placed in direct sunlight, with the exception of those made on Cibachrome paper. Prints may be displayed behind glass unless they are being formally exhibited. The glass physically protects the surface of the print from damage. Non-glare glass is available, although it is expensive, but it does avoid the unattractive reflections which usually detract from photographs displayed in this manner. One of the most attractive features about black and white photographs is the quality that their surface texture gives. This quality is lost when the print is put behind glass and it is worth investigating various methods of mounting prints directly on to board, or thick card particularly if they are intended for exhibition.

Wet mounting involves the use of special glues to attach the print to a backing. Alternatively, prints can be dry mounted by using a special heat-sensitive adhesive tissue placed between the print and the backing and applying heat with a warm iron. During the process the surface of the print must be protected by covering it with a spare sheet of photographic paper.

Aerosol adhesives can also be used. They have the advantage of being convenient and fairly clean in use. Some of these preparations allow the print to be repositioned after it has been initially stuck down. Other adhesives are available which remain tacky so that new photographs can be substituted on to the mounting board at a later date. To be able to do this both the paper of the print and the backing board must be fairly non-absorbent otherwise the bond between the two becomes permanent.

Professional photographic finishing laboratories can also laminate prints between two sheets of special plastic. This method of presentation is inexpensive and very useful if you expect that your material will receive a lot of handling.

There is a wide choice of different slide mounts available and because many colour processing laboratories return transparencies unmounted, it is worth

discussing the merits of the various alteratives. In terms of cost, the cheapest are made of card, usually coated with an impact adhesive. If you are inclined to buy such mounts in bulk you may find that the adhesive is no longer effective if the mounts are unused and exposed to the air for a long period of time. Plastic mounts are slightly dearer but are much more durable. They are very suitable if you intend to have your work published because the transparency can be easily removed and replaced by the printer. Cardboard mounts have to be torn or cut apart and one can encounter many problems having to undo and remount an inadequate job done by a busy printer.

Plastic mounts with glass windows offer increased protection for your transparencies. They are especially suitable if one intends to do a lot of slide shows. This also applies to plain plastic mounts but card mounts are inclined to bend and can become jammed in some projectors. Glass mounts prevent the slide from popping as it expands in the heat of the projector lamp, and avoid the need to refocus during projection. However, it is recommended not to send glass-mounted transparencies in the post. Even if they are packed extremely carefully, glass is fragile, and it is not worth the risk of the transparency being damaged by fragments of glass. Some glass mounts are also prone to Newton's rings, caused by the interference of light when glass and slide are very close to each other. This can cause annoying patterns of dark and light concentric rings when the slides are projected. However, anti-Newton glass mounts are available which have been slightly etched so that this problem does not occur. If the atmosphere in which the slides are stored is slightly damp one can occasionally find that their surface may stick to the glass and it may be impossible to avoid doing permanent damage.

SLIDE SHOWS

Most people interested in mountain photography have seen breath-taking slide shows given by professional mountaineers. To give a good slide show you have got to have good material. If you go on an expedition and intend to give illustrated lectures on returning a great deal of thought must be given to your photography, despite the many other demands on your time and energy.

It is worthwhile to actually begin to put the show together in your head while you are in the mountains. Imagine how you would like the lecture to open and think of the sorts of highlights that will be required to give the presentation pace and a satisfactory end. This often is a very constructive and creative way of getting better photographs.

A good slide show needs pace and a sense of action. Domestic and static shots have their place but one also needs photographs of people doing things and actually involved in moving, climbing and surviving in the environment.

Having got a good selection of photographs one must then consider how to present them. The illustrated lecture should have all the features of an entertaining story, that is, a beginning, middle and end, with highlights, suspense and humour interspersed to give pace and flow to the narrative. Your photographs need to introduce the venture to your audience. A title slide can easily be produced by photographing lettering against a plain or white background. In the latter case this can be sandwiched with an appropriate transparency to give a very professional opening. It may be worth taking several photographs with this purpose in mind while you are in the mountains. Alternatively one can have title slides made by a professional laboratory.

You should introduce the individual members of the trip and explain the objectives of the expedition and some aspects of its preparation and organisation.

Keep your introduction short and try to get into the substance of the show as quickly as possible. By varying the subject matter, rather than sticking rigidly to one theme, you are more likely to maintain a lively and entertaining programme.

If you want your audience to leave favourably impressed it pays to introduce the major events or highlights towards the end, provided that this does not seriously affect the continuity of events. While trying to achieve this don't impoverish the beginning of the show. In some cases it may be best to space the highlights out fairly evenly, just keeping the very best until last.

The conclusion is also best kept short and as smooth as possible with a few carefully chosen photoraphs which sum up the achievements of the venture.

A fluent and professional programme is also enhanced by avoiding some simple mistakes. Check that all the electrical fittings on the projection equipment are compatible with those at the lecture hall. When loading the magazines see that all the transparencies are securely mounted and placed correctly so as not to project upside down or sideways (a basic but frequent error). Also take care to ensure that all slides are free from dust or hairs, by examining them against a bright light, as these can be very distracting for an audience you want to be concentrating on your talk. An important precaution is to arrive at the venue well before the performance (at least two hours). This will enable you to resolve any projection problems involving the focal length of projector lenses and screen sizes and also allow sufficient time to have a quick run through the programme to check that the equipment is working correctly and that the magazines have been properly loaded. On spring/summer evenings ensure that the hall is properly blacked out or, if this is impossible, that the screen is positioned in the best location to avoid any chinks of daylight. Have spare projector bulbs near at hand and be sure that you know how to replace one. The knowledge that everything will work all right and that there should be no slip-ups is a great boost to self-confidence.

Two projectors worked in synchrony and made to fade one picture into the next make an especially pleasing presentation. Many audio-visual hire companies can offer such equipment but it may be expensive. It is worth enquiring whether anyone you know who works in a large organisation using such equipment, may be able to borrow or hire it for a nominal charge on your behalf.

Expensive sophisticated equipment is not essential to a successful slide show if you have good photographs and a single projector of high quality may still be sufficient. Whatever the situation it is vital to check that you have a lens of the correct focal length for the job. A table has been included in the Appendices which indicates the focal length of the lens required for a given screen size and projection distance.

CONCLUSION

After reading this book the reader may be inclined to feel that it seems a very complex subject. You may wonder how to keep all this information in your head so that it is accessible at the right time. The truth is that it all takes time and experience. The best way to learn is to go out and take photographs. It's like learning to play an instrument or ride a bike, gradually it all begins to fit into place, but you never stop learning something new.

I have tried to warn against the idea that there are necessarily right and wrong ways of doing things in photography. Even mistakes can ultimately be beneficial in exposing the photographer to a new technique or a new way of looking at a familiar subject.

One sure way of improving as a photographer is to make yourself as open as possible to different styles and approaches to the subject. There is nothing as encouraging (and sometimes discouraging) as looking at the many beautiful photographs which have been taken. In the next few pages I have suggested just a few books which I know to contain some excellent examples.

It does surprise me, considering the wealth of classic landscape photographs, that this is not balanced by many great photographs of climbers. I have already drawn a parallel between war and mountaineering documentary photography. When one considers the powerful images which exist of the former it does seem to me that the latter is lacking in truly great photographs of the climbers themselves. Perhaps this is one area which should be developed by a new generation of mountaineering photographers.

APPENDICES

THE USE AND RECONSTITUTION OF THE DESICCANT, SILICA GEL

Silica gel is usually sold in the form of white granules contained in paper or fabric sachets. The loose variety of the desiccant is often impregnanted with cobalt chloride which acts as an indicator of the state of the desiccant, ie it is blue when dry and pink when wet. The desiccant is most conveniently used in sachets.

Silica gel is like a sponge; it absorbs moisture in considerable quantity. It does not react with most common materials, and it can be reused after it has been dried in an oven at about 175°C (350°F). Forty grams, or 1.5 ounces, of silica gel are enough to keep the relative humidity at a reasonable level in a volume of about 30 cubic decimetres, or 1 cubic foot, of sealed space.

The desiccant is not recommended as a means of protecting processed negatives, slides, or prints in long-term storage. For long term storage use suitable impervious storage envelopes or packing and then keep the package in conditions that are as cool as possible.

NB. A substance which can be considered an alternative to silica gel as a last resort is rice and should be dried in the same manner. In use it is estimated that it is approximately one-tenth as effective as a desiccant.

EXPOSURE COMPENSATION FOR BRIGHT SUN ON SNOW: A SUMMARY

	Front-lit	Side-lit	Back-lit
Scenics	1 stop more	1 stop more	1 stop more
Close-ups of people	Up to 2 stops more	2 stops more	2 or more stops

This exposure table is based on general reflected light readings above the snow-line. If you use an incident light meter it pays to close down one stop on the reading, particularly if working at altitude. Remember, if in doubt it is best to err on the side of underexposure especially when shooting transparencies. When taking close-ups of white caucasians it is best to base the exposure on a reflected light reading from the skin. Give half to one stop more than this for dark complexions.

EXPOSURE COMPENSATION FORMULA FOR CLOSE-UP PHOTOGRAPHY WHEN USING EXTENSION TUBES

When using extension tubes the aperture indicated on the lens is no longer correct. To calculate the correct lens aperture use the following formula:

$$Ef = If \times \frac{FL + EL}{FL}$$

where EF is the effective f-stop or aperture value,
 If is the indicated f-stop or aperture value set on the lens,
 FL is the focal length of the lens.
 EL is the length of the extension tube.

NB. There is no need for exposure compensation when using cameras with TTL metering. However, compensation is required if you use flash and you wish to calculate the correct aperture setting for a given flash to subject distance. In this case you will also need the formula quoted on page 60.

CHECKLIST FOR EXPEDITIONS AND LONG TRIPS

Before going overseas:
1. Investigate climate, weather, etc of destination to ensure visit occurs at best time of year.
2. Check with consulate or embassy of country regarding any problems in bringing photographic and other equipment. Enquire about any potential problems regarding areas or subjects which may be sensitive with respect to photography.
3. Make a brief examination of photographic work already done on country area/subject(s) of interest.
4. (a) Have cameras and lenses checked and, if necessary, serviced. Particular attention should be paid to lens focus and aperture controls, camera shutter accuracy and metering, plus general state of wear and tear.
 (b) Try to obtain useful spares and advice on emergency repairs. See 'Suggested repair kit' below.
5. Purchase film and other equipment. Make sure the latter is used and tested thoroughly before departure.
6. Make or purchase any specialist equipment, bags, cases and belts.
7. Obtain extended insurance on photographic and other equipment.
8. Check with airlines and all connecting flight operators over cabin and general baggage allowances.

SUGGESTED REPAIR KIT TO INCLUDE:

1. Lens blower brush, lens tissues and/or cloth.
2. Unbreakable bottle containing lens cleaning fluid/pure alcohol.
3. Dusting aerosol for cleaning camera lenses and bodies.
4. Selection of plastic bags, rubber bands and dry silica gel.
5. Changing bag.
6. Four to five watchmaker's screwdrivers, blade type.
7. One to two watchmaker's screwdrivers, posi-drive type.
8. Pair of small pliers.
9. Multi-purpose pocket knife with scissors, etc.
10. One or more pairs of fine forceps.
11. Tube of clear impact adhesive, super glue and adhesive tape.

SUGGESTED CAMERA SPARES FOR AN SLR:

1. Camera and flash batteries, individually packed.
2. Small split rings for camera strap.
3. Selection of small screws.
4. Spare top cover for camera; battery and motor drive cover plates.
5. Replacement pentaprism and viewfinder lens.
6. Spare lens cap(s) and hood(s).

SUGGESTED PHOTOGRAPHIC EQUIPMENT:

1. SLR camera body, manual type.
2. Compact camera or spare SLR body.
3. Lenses
 (a) Wide-angle, eg 28 mm or 35 mm
 (b) Wide aperture lens for photography in subdued light, eg standard lens.
 (c) Medium telephoto lens, eg 135 mm.
4. Close-up attachments, eg supplementary lenses or extension tubes.
5. Compact electronic flash gun.
6. Lightweight, sturdy tripod and cable release.
7. Hand-held light meter with incident/reflected light measuring capability.
8. Skylight filter for each lens, polarising filters and stepping rings.
9. Lens hood to fit each lens.

SCREEN WIDTH/PROJECTION DISTANCES

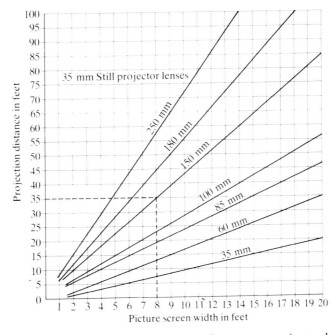

The graph is a guide to choosing the correct projector lens for a given screen width and distance between screen and projector. For example, if the screen width were 8 feet and the projectors needed to be about 35 feet from the screen to allow sufficient room for a seated audience, then a 150 mm lens is required on the projector.

GLOSSARY

TECHNICAL TERMS NOT ALREADY EXPLAINED IN THE TEXT

Alpine style. A continuous, rapid, mountaineering ascent made without establishing intermediate, semi-permanent camps or stockpiles of food and equipment.

Anorak. Loose fitting, waist-length smock with hood. Usually made of wind and waterproof fabric. Traditionally worn by outdoorsmen.

Aperture. Adjustable, circular hole in lens diaphragm which allows light to pass through the lens and reach the film.

ASA. Abbreviation for American Standards Association. An arithmetically progressive rating of the sensitivity of film to light, eg ASA 25 film is half as sensitive to light as ASA 50 film. Superceded by the ISO measure in 1985.

Automatic flash. Electronic flash equipped with a photo-electric cell which measures the light reflected from the subject and limits the flash duration appropriately to provide correct exposure.

Belay. Point on an ascent where a climber anchors himself to the rock or ice face in preparation for paying in, or out, the rope attaching him to his companion.

Bivouac. Temporary, usually improvised, over-night camp established by climbers during an ascent.

Bleaching, of highlights. Loss of detail in brightest areas of photograph due to over-exposure of film.

Bracketing. Making a number of exposures at half or one stop intervals above and below a suggested meter reading where the exact exposure required is difficult to determine.

Chromatic aberration. Inability of a lens system to bring light of different wavelengths to the same point of focus. This can be compensated for by cementing different lenses (or elements) together to form a compound lens.

Coupled light meter. A light meter, integrated into the camera, which is connected electrically or mechanically to the lens diaphragm causing it to open or close the aperture and give an appropriate exposure for a given shutter speed.

Cuban hitch. Shoulder harness designed to support a weight on the chest.

Definition. The appearance of sharpness and lack of graininess in a photograph.

Diaphragm. An opaque partition of partially overlapping blades (usually of metal foil) within a lens which can open or close a central hole, called the aperture. The diaphragm is also sometimes known as the iris.

Dichroic filter. A fade-free filter which relies on the interference of light by coatings of metallic complexes on the glass. This limits the wavelengths of light transmitted by the filter.

DIN. An abbreviation for Deutsche Industrie Norm. A logarithmically progressive rating of the sensitivity of film. It is an alternative to the ISO system of film speed rating.

Discharge tube. Tube of inert gas through which a high voltage spark is discharged in an electronic flash gun.

Electromagnetic radiation. Radiation associated with electric and magnetic fields consisting of waves of energy, eg visible light, infra-red, ultra-violet, X-rays, radio waves etc.

Emulsion. The light-sensitive coating on photographic films and paper. Consists of halides suspended in gelatin.

Exposure latitude. The factor by which the minimum camera exposure required to give a negative with adequate shadow detail may be multiplied without loss of highlight detail.

Fixed lens. See prime lens.

f-stop. Notation for the size of the aperture of a lens. The smaller the f-stop of a lens the more light it transmits. If the aperture is opened by one f-stop, twice as much light can strike the film. If the aperture is closed by one stop then half as much light can strike the film.

Fog, of film. Unintentional exposure of film by non-image forming light which causes a loss of image contrast.

Focal plane. The plane in which the lens forms a sharp image.

Focal plane shutter. A type of camera shutter composed of two blinds which move across the film area very close to the focal plane. They have an adjustable gap between them which determines the length of time the film is exposed to light.

Grain. Size and distribution of the grains of silver in a photographic emulsion after the light-sensitive silver halides have been exposed and developed.

Internegative. A negative image made by rephotographing a positive image such as a transparency or print.

Iris blade. One of the blades making up the lens diaphragm or iris.

ISO. Abbreviation for International Standards Organisation which is now used to prefix standard film speeds, replacing ASA in 1985.

Leaf-blade shutter. A type of camera shutter made of overlapping blades of metal foil.

Macrophotography. Extreme close-up photography using a camera where the image formed is larger than life size, but not greater than × 10 magnification.

Monochrome photography. Photography where the image is composed of variations of tone, as in black and white photography, or of one main colour.

Multi-coating, of lenses and filters. Multiple coatings of metallic compounds which reduce the reflection of light within a lens at air/glass surfaces. This reduces the amount of non-image forming light-striking the film (ie flare) and is more effective than a single coating.

Parallax. The difference in the image seen through the viewfinder of a non-reflex camera and that taken by its lens. This is because each is 'seeing' the subject from a slightly different angle.

Prime lens. A lens with one focal length, ie not a zoom lens. The same as a fixed lens.

Refraction. The bending of light rays as they pass from one transparent medium to another.

Saturation of colours. Rich, bright colours produced by slight underexposure of transparency films and the reduction of non-image forming light which strikes the film, eg haze, reflections, etc.

Sharpness. The subjective appearance of how well edges and lines are reproduced on film and photographic paper.

Sticht plate. A friction plate used when belaying to slowly arrest the rope of a falling climber.

Vignette. Darkening of the corners of a photograph caused by the obstruction of the light reaching the film.

FURTHER READING

GENERAL TECHNIQUES

1. Freeman, Michael, *The 35 mm Handbook*. Windward (Leicester) 1980.
2. Hedgecoe, John, *The Book of Photography*. Ebury Press (London) 1976.
3. Jacobson, Ralph, E., Ray, Sydney F., Attridge, G. G. and Asford, N. R., *The Manual of Photography* (revised edn). Focal Press (London) 1978.
4. The Editors of Time-Life Books, *Caring for Photographs*. Time-Life International (Nederland) NV, 1978.
5. The Editors of Time-Life Books, *Colour*, Time-Life International (Nederland) NV, 1972.
6. The Editors of Time-Life Books, *The Print*, Time-Life International (Nederland) NV, 1970.

NATURE PHOTOGRAPHY

1. Hoskins, Eric and Gooders, John, *Wildlife Photography – a field guide*, Hutchinson and Co Ltd (London) 1973.
2. Nuridsany, Claude and Pérennou, Marie, *Photographing Nature*, Kaye and Ward (London) 1976.

EXPEDITION PHOTOGRAPHY

1. John, D. H. O., *Photography on Expeditions*. Focal Library (London) 1965. See also photography appendices in:
2. Bonington, Chris, *Annapurna*, Cassell (London) 1971.
3. Bonington, Chris, *Everest South West Face*. Hodder and Stoughton (London) 1973.
4. Bonington, Chris, *Everest the Hard Way*. Hodder and Stoughton (London) 1976.

MOUNTAIN WEATHER

1. Unwin, David, J., *Mountain Weather*, Cordee (Leicester) 1978.

 The following contain some excellent mountain and climbing photographs:
1. Adams, Ansel and Muir, John, *Yosemite and the Sierra Nevada*. Houghton Mifflin Company (Boston) 1948. (Out of print and possibly difficult to obtain, but showing some of the master's early and lesser-known work).
2. Chouinard, Yvon, *Climbing Ice*. Hodder and Stoughton (London) 1978.
3. Messner, Reinhold, *K2*. Kaye and Ward (London) 1982.
4. Rébuffat, Gaston, *The Mont Blanc Massif – the hundred best routes*. Kaye and Ward (London) 1974.
5. Rowell, Galen, *High and Wild*, Sierra Club Books (San Francisco) 1979.
6. Rowell, Galen, *In the Throne Room of the Mountain Gods*. Sierra Club Books (San Francisco) 1977.
7. Shirakawa, Yoshikazu, *Himalayas*. Abrams (New York.) 1976.
8. Wilson, Ken, *Classic Rock*, Granada (St Albans) 1978 (now Diadem).
9. Wilson, Ken, *Hard Rock*, Granada (St Albans) 1981 (now Diadem).
10. Wilson, Ken and Gilbert, Richard, *The Big Walks*, Diadem Books (London) 1980.
11. Wilson, Ken and Gilbert, Richard, *Classic Walks*, Diadem Books (London) 1982.

INDEX

Page number references to illustrations and captions appear in *italic*.

abseil, *88*
accidents, 85
action photography, 14, 53–4
aerial photography, 65–6
Agfa, 14
alpine style, 84
altitude, 84, 85, *89, 90*–3
angle of view, 10
animal photography, 63
Ansel Adams, 32
aperture, 32, 54–5
atmospheric haze, 11, 20, 55–9, 65–6
automatic exposure system, 4
autowinder, 19

back lighting, *35, 37, 38*
batteries, 30, 70, 73, 77
black and white photography, 14, *15*
blower brush, 26, 102
bracketing exposures, 36

cable release, 18, 24
camera
 care, 25–9, 66–9, 77–81
 carrying, 22–4, *26*, 74, 79–81, *81*, 89, 92–3
 cases, 25, *26*, 80, *81*
 holding, 7, 24
 loading, 22–4, 67–8
 rangefinder, 5
 repair, 6, 29–30
 servicing, 76
 shake, 7, 10, 24, 66
 single lens reflex, 5–7
 straps, 25, 80, 89
 support, 18–19, 24, 72, 81–2
 viewfinder, 4–5
 winterisation, 77
captioning photographs, 96
cataloguing photographs, 96
changing bag, 30
checklist for expeditions, 102–3
chromatic aberrations, 6

cibachrome prints, 97
climbing, 25, 84–90
close-up photography, 61–2
 exposure compensation for, 102
 reflector for, 62
clothing, 25, 82
cold, 30, 77–8
composition, 45–9
contrast, 40, 91–2
contre jour, 43
coupled light meter, 4

definition, 4
delay timers, 24, 93
depth-of-field, *6*, 7, 10, 11, 49, *52*, 54–5, 61, 67, 90
displaying photographs, 97–8
distortion, 7, 64
dust, 78

editing, 95–6
Ektachrome, 14
exposure
 black and white film, 14, 33
 colour film, 14, 32–3
 compensation, 102
 for landscapes, 37
 general, 17, 32–43, 68, 91–2
 in mist and clouds, 37
 in snow, *35, 36, 36*–7, *89, 92*
 latitude, 14
 meter, *see* lightmeter
 zone system of, 43–5
extension tube, 61
eye-cup, 77

film
 black and white, 14–15
 brittleness in cold, 77
 care of, 25, 30–1
 colour, 13–14
 defects on, 67–8

development of, 14
infra-red, 16
quantity for expeditions, 72–3
size, 4
filters
 for black and white photography, 33,
 57–9, 65, 68
 care of, 21, 26–8
 exposure compensation, 58–9
 general information, 20–1, 55–7,
 73–4
 polarising, *2, 21,* 33, *56,* 56–7, *58,* 65,
 68, 91
 skylight, *11,* 55–6, 65, 68, *89,* 91
 special effects, 57, *58*
 stack caps, 21
flare, 12, 67
flash photography
 bulb, 19
 electronic, 19–20, 59–61, *60,* 72
 guide number, 19, 60
 shutter synchronisation speeds, 59
flower photography, 62, *62*
focus
 selective, *52,* 54–5
foreshortening, 64
fungus, 30, 79

gloves, 78
grain, 4
grey card, 17, 35

heat, 30, 76
highlights of prints and transparencies,
 33
humidity, 30–1, 77, 79

improvising equipment, 25–6
infra-red trigger device, 93
injury, 85
insurance, 74–5
internegatives, 14, 15

Kodachrome, 14
Kodak, 14

landscape photography, 71
lens
 cap, 80
 care, 26–8, 77–80
 hood, 12–13
 interchangeable, 5, 7–12

long-focus, 10
macro, 7
multicoating, 12
repair, 29–30
standard, 7
telephoto, 10–11, 63, 71–2, 78
teleconverter, 10
wide-angle, 7, 71
zoom, 12
light meter
 coupled, 4
 failure of, 30
 hand held, 16–17
 incident, 35
 integrated, 17–18
 in simple viewfinder cameras, 5
 TTL (through the lens), 17, 35, 78

mites, 79
monopods, 19
motor drive, 19
mounting prints, 97
mounting transparencies, 98
multi coating, 12

nature photography, 61–3

parallax, 4, 5
people, *72, 73, 87*
portraits, 40, 71, *90–1,* 92
projection distances, 103
protecting photographic equipment,
 24–5, 80–2

radio controlled trigger device, 93
record photographs, 64, *65*
recording photographic details, 63–4
repair, 6, 29–30

saturation of colours, 56, 65
selective focus, *52,* 54–5
self-timer, 93
shadow detail, 33
shutter speed, 32
side light, *3*
silhouette, *26*
silica gel, 29, 74, 101
slide shows, 98–9
SLR (single lens reflex) camera, 5
snow blindness, 92
spares, 72
specialist equipment, 25–6, 79–82

stack caps, 21
static electricity, 67, 77
stepping rings, 20
sticht plate, 87
storing photographs, 96–7
supplementary close-up lens, 61

theft, 25, 76–7
tramlines, 67
travel, 25–8, 70, 75–6
tripods, 18

ultra-sonic trigger devices, 93

viewfinder cameras, 4

waterproof cameras, 5
weather, 82–3
weatherproof cases, 79
wildlife photography, 71–2
winterisation of cameras, 77

X-rays, 75–6